Prototype — Interdisciplinary / Prose

RRP £15
ISBN 978-1-913513-82-5
Publication Date: 13 November 2025
Extent: 145 × 208mm, 144pp
For PR enquiries contact Jess Chandler
jess@prototypepublishing.co.uk

Significant Others
a collection of texts by frank r. jagoe

You ask of my companions. Hills, sir, and the sundown, and a dog as large as myself that my father bought me. They are better than human beings, because they know but do not tell.
Emily Dickinson

Recognition is the misrecognition you can bear.
Lauren Berlant

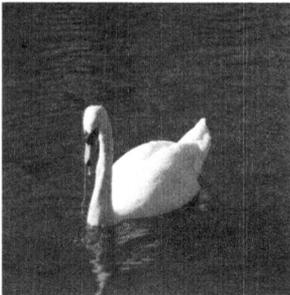

Wie have a highly developed taste system through whych wie navigate world. Oure entire skin is covered in taste buds, whych become more concentrated in barbels around oure mouth. Through these wie can taste prey, wie can taste environment, wie can taste excrement, and wie know which way to move.

As wie move into Piccadilly Circus tube station wie can taste layers of grey dirt accumulaten at the edges of steps. Steps are ston, wie can tell yugh this for certain. wie taste flattened, thick roundness. The grime, wie do not know what itt is. There is flesch, there is bits of flesch, and there is soil, from shoes, and there is leafs, and there is other things, itt is complecks and hideous and as oure skin slides over itt, itt passes into us.

On prickly plush of the underground seats, wie taste sweat of countless, nameless strangers, bisected by single, long red hair, bulbous at one end where itt once attached to head. There is other things here too, saliva, urine, bitter tang of stale vomit, nylon fibres, spun from oil, spun from long dead things, thei taste of things too. Everything wie touch, wie taste. wie are eten everything, wie are unabel to filter it out, itt brushes against oure skin and moves into oure digestive tract, a solid, undigestibel, lumpen mass hardenen in stomach. Some days wie are so overwhelmed by taste and wie cannot leave bed, but as wie roll around in sheets, wie taste oure own body and wie are disgusted, and wie do not know how to shut itt out, how to sever connectioun to world. wie must always be touchen something, and so wie are always tasten, always eten, always absorben, constant, horrific intake which builds up in toxic load. wie carry this in oure tissues, in oure softe parts, like piles of soil in silken bags.

Take hede vn to my fygure here abowne
And se how sum tyme I was full fresche & gay
Now turned to wormes mete & corrupcion
Bot fowle erth & stynkyng slyme & clay
Attende þerfore to þis disputacion writen here
And write it wisely in þi hert fre
For þat þi saule be saued þu may lere
Bot sic what þu art & here aftyr sal be
When þi leste dwere ... veut mors te superare
Bot quia þi grisse grenes. bonii & mortis meditari

You live in the city. The speed of the city is not determined by the seasons, by the growth of trees, by rainwater levels, by the levels of light and intensity of the sun's heat. The speed of the city is determined by capital, and the hoarding of resources, and the transformation of resources, most notably property, into commodities.

Anywhere you stand still, you must pay for it. People perpetually rush around you: in order to avoid standing still, in order to avoid paying, in order to reach a place in order to make the money they need in order to be able to stand still.

You cannot speak their language. No, you can speak their language, you just cannot keep up with their speed. By the time you have processed one sentence they have spoken, they have said five more sentences, which you have entirely missed and must ask them to repeat. You feel totally alone.

The ecosystem of the city bears no relationship with the soil, with the soft earth, and below that the bedrock. Floating on a raft of concrete and tarmac, the ecosystem of the city is a self-contained terrarium of human infrastructure and scavengers. The city must be here because of the bedrock, because the specificity of the ecosystem allowed it to be born. But the city has moved past it, or chooses to ignore it; the city drifts gently across the land, rootless, because the city believes itself to be beyond natural limitations.

One night you are followed home by a fox, belly fat with unborn babies. She runs to catch up with you, as your panicked mind attempts to remember if wild animals are carriers of rabies in this country. You are alternately jogging towards your home, stopping to scream at her, stopping to make yourself larger to intimidate her (arms out, waving scarf; it does nothing), and trying to locate your house keys in the multitude of pockets across all of your different garments. The fox jogs to catch up. Still unclear on the rabies question, you throw your takeaway chicken wings at her and she pounces on them, snarling as she tears the paper bag open. This is hunting.

Thin walls, the results of cheap and quick building methods, a greater return on investment. Thin floors, no insulation. The hundreds of people whose lives you brush against on the tube, on the bus, walking from your house to the Co-op to buy a frozen pizza and four apples. You are perpetually infected with the routines of everyone. Your neighbours, the people on the street,

the cars rushing by, the circus school in the yard behind your house, the bar and music venue two doors down, the café directly below your house, the person upstairs who works in the city and leaves the house every morning at 5.30am to go running, the neighbour in the flat to the right who has just had his benefits cut, again, and who cannot afford to pay for adequate care, struggling again to get up the stairs, the flat to the left populated by BA students who drink Glen's and play Cluedo all night. You have to leave the city.

You are surrounded by the jagged hills of lime-stone, now. The thick stone walls of your home surround you, too, wadding you from the world. You recently started walking to the standing stones in the village, in order to sing to them. It is not that you are not impacted by the routines and schedules of others anymore, it's that these others are now the stones that surround you, not your neighbour Deborah, who works in in-house marketing for Barclays and listens to violent true crime podcasts on her morning jog. Silence and solitude, a sense of belonging in this place, this specific place. You see a wild boar running across the road and you understand for the first time in many years how cold and open and expansive and harsh the world can be. It is then you fall in love with the world and it is then you fall in love with a person.

> *Empedocles: Behold the sun, every-where bright and warm, and all immortal things that are bathed in heat and bright radiance. Behold the rain, everywhere dark and cold; and from the earth issue forth things close-pressed and solid. When they are in strife all these are different in form and separated; but they come together in love, and are desired by one another.*

The world moves by Love and Strife. Two opposing forces by which beings are drawn to each other, then repulsed by each other. The limestone cliffs surrounding you are formed from the micro-scopic exoskeletons of marine life, who bonded together so tightly it could almost be for eternity. This is formed through Love, this is a form of Love: the lives of trillions of marine organisms compounded into rock. A gentle drift ever downwards onto the seabed, almost silent, gently covered in a blanket of other marine skeletons, a comforting weight that starts to press harder, and harder,

and harder, until. Life does not end, you realise, it only transforms. It is love that draws you towards stone.

At your most acutely ill, told that you could die in your sleep at any point, you felt a somnolent relief in the idea of drifting into an endless slumber, of being broken down and reconstituted as other lives. You wanted to die in the sea, to be absorbed by the ocean, to slowly, through the lives of countless fish and marine vertebrates, drift towards the floor, a fine dust of life, falling, settling, waiting to become stone.

> *Empedocles: For I have been ere now*
> *a boy and a girl, a bush and a bird and*
> *a dumb fish in the sea.*

Flesh can become stone can become flesh: all are living, it is simply a question of speed.

> *Alfred North Whitehead: In fact life*
> *itself is comparatively deficient in*
> *survival value. The art of persistence*
> *is to be dead. Only inorganic things*
> *persist for great lengths of time. A rock*
> *survives for eight hundred million*
> *years; whereas the limit for a tree is*
> *about a thousand years, for a man*
> *[sic] or an elephant about fifty or one*
> *hundred years, for a dog about twelve*
> *years, for an insect about one year.*

The calcium supplements you take are produced from quarried limestone. Concerned about your osteoporosis, they occasionally ask if you have taken this pill, and if not, why not take it now. One in the morning and one in the evening, thick chalky slabs derived from rocks. You had misunderstood this care and concern as a desire to protect your future together. Sometimes emotions feel so deep you think they exist outside you as living entities, and it is isolating to realise you feel something alone, that the feeling is bound within your skin. You are just flesh, a bag of fleshy feelings, meat on a mineral scaffold, and you will become stone, and this stone will become flesh, an endless cycle of hard and soft, slow and quick. Flesh can become stone can become flesh.

> *Empedocles: Thus do all things draw*
> *breath and breathe it out again.*

The Western colonial project told you that the earth is dead. Not even dead, it was never alive. Capitalism told you that the world exists to serve humans. Western Christian culture told you that being human is almost the highest form of existence, second only to the angels. At the bottom, the minerals, the inert matter, non-sentient, dumb. The earth cannot feel pain if it does not live. Living beings transformed into resources, resources transformed into commodities. The stones are alive, and they are speaking to you, if you would only stop to listen.

She told you that the key is to stop trying to rush it. One hour, she said, is, I don't know, 10,000 years in limestone's lifespan. A second lasts – uff, I can't do the maths, you get it. The communication that exists between you and the cliff is not going to look like human language. But language is everywhere, you just need to figure out how to hear it, or read it, or perceive it somehow – it might not be through sight or sound. She had only successfully talked with trees, had never attempted to be in conversation with rocks, she did not know how to talk to them, but she knew how to listen: she had heard bitter words spoken and anger articulated by stone when the earth was plundered, at the sites of mining and quarrying near where she lived. And they have their own person-hood, their own mood, you have to allow them that, she continued. A flash of anger for a rock is going to last longer than your entire life, which is pretty wild. Trees can be pretty rude, too, she said, pointing to an ash. That one's a little bitch.

Sitting by the cliff, you are embedded in a region where Western geology as a science began. The international geological timescale, a language imposed globally by an imperialism of ideas, is named after the geology of South Wales: the Cambrian (the Latin name for Wales); the Ordovician and Silurian periods (named after Welsh tribes); numerous other subdivisions named after Welsh places: Arenig, Llanvirn, Llandeilo, Llandovery, Hirnant and Tremadoc. Not all terms are oriented to this place, and since the Devonian period (after Devon, southwest England) the naming of geological formations pulled from locations across the globe. But you are in an area where stones began to be perceived as a rich text to be read, an archive of deep time, even if that attempt to read them was embedded within industrial capitalist extractivism. Is reading the past from geology engaging in a language of the stones, or is it turning beings into artefacts?

Robin Wall Kimmerer: Not everyone will get it, though; the language of stone is difficult. Rock mumbles.

You run your hands along the surface of the cliff, gently, so gently it is just the whisper of a fingertip, stroking the cold stone with warm flesh. Your fingers pause at a small protrusion, a tiny dome erupting like a rocky growth. Your fingers pause, and then begin to trace around the mound in a circular motion, first one way, then the other, then softly, ever so softly, grazing the tip once, then again, before moving back to the long strokes across the face of the cliff. It's an invitation to talk, softly teasing the limestone surface, communicating through touch, *I am here.*

> *Audre Lorde: When released from its*
> *intense and constrained pellet, [the*
> *erotic] flows through and colors my life*
> *with a kind of energy that heightens*
> *and sensitizes and strengthens all my*
> *experience.*

In Western antiquity, there was much debate as to whether stones had sex, requiring first the reification of sex into specific acts, the siloing of eroticism into only certain activities, and the supposed intrinsic connection between desire, love, procreation, and life force itself. Theophrastus writes of 'stones that give birth to young'. In *Physiologus*, fire rocks, or pirobili, are binary gendered stones who are inert when separate, but who ignite and burn when the male approaches the female.

> *Jeffrey Jerome Cohen: The Book of John*
> *Mandeville takes lithic sexual differ-*
> *ence, fecundity, and creaturely possibil-*
> *ity to their limit, describing diamonds*
> *that mate, reproduce, live [...] Dia-*
> *monds, we are told, come in two forms,*
> *male and female. Erotic inclination*
> *brings the gems into union, but not*
> *necessarily as couples, and without the*
> *incendiary and moralized results con-*
> *straining firestones. Promiscuous in*
> *their commingling, diamonds under-*
> *take a slow lithic coitus that within its*
> *own geologic time creates ever more*
> *glistening and libidinous rocks, a*
> *slow-motion petric orgy:*
> * 'They groweth togodres [together],*
> *the maule and the femaule. And they*

beth noryshed [are nourished] with the
dew of hevene, and they engendreth
comunely [in common] and bryngeth
forth other smale dymaundes, that
multiplieth and groweth all yeres.'
Though gendered, these amatory
rocks are not exactly heteronormative.

In the elision of desire with reproduction, in the assumption that reproduction is necessary to prove life, it becomes easy for Western science to argue that stones are not alive, and that stones do not desire. They are not moved by Love or Strife, they feel nothing. You are caressing the limestone cliffs, pleasing your fingertips, seducing the rock. You were wrong to say that you are just flesh, and that your emotions are isolated, cut off from anyone else. Love and Strife move the world, binding every being together, feelings are always already shared, even if not mirrored.

James Baldwin: You think your pain
and your heartbreak are unprece-
dented in the history of the world, but
then you read. It was Dostoevsky and
Dickens who taught me that the things
that tormented me most were the very
things that connected me with all
the people who were alive, who had
ever been alive.

Your concentration starts to wane as thoughts begin to pour in, first in a steady drip until your defences burst and you are flooded with concerns. You are trying to make yourself less available, you are trying to shut out the background anxiety of not checking your phone. Stay present, stay with the present desire. The limestone cliffs do not speak back, do not indicate if they are moved by Love or Strife, do not express their desire or repulsion, only their seeming indifference. You want to argue with the clinical reductionism of the scientific method, but you can't hear what the cliffs are saying. They were brutally exposed to the air through industrial quarrying over centuries, they should be buried under layers of topsoil, they should be held in an embrace with more limestone, a smooth and unbroken sheet across the hill: instead they have been cleaved open, fragments dotted across the grass. Why would they want to talk to me, you think, what would they have to say. Learn how to listen, your friend's voice speaks to you from your

past conversation; understand how they are speaking to you, before you try to understand what they are saying. The stone is cold to the touch, and rough against your fingertips. This is full of meaning, even if you do not know what it means.

The coldness of stone, its seeming immovability, its alleged lifelessness, its presumed permanence and unchangeability: all have made stone a fertile site for Western metaphor. A heart of stone. Stone faced. To be set in stone. 'God knows I can't contradict you Cary; I'm as ignorant as a stone' (Brontë, *Shirley*). How strange, to see stone as inactive, inert, unfeeling matter. How strange, to see stone as lacking in feeling. A building material, a surface to be carved, cold and heartless, a dead substance, not a being who can and does act in the world. You think of softness as yielding and hardness as rejection because your touch language, your erotic grammar, is tied to human flesh, to softening and opening and dilation and wet and. You want to try and read below the obvious metaphors, you want to give the cliff a chance to reply.

> *Mel Y. Chen: Let me say more about a particular object—a stone—as it has been encoded and applied to human sexualities. Within butch or femme lesbian culture, being 'stone' or 'stone butch' is a particular erotic and sexual formation. It does not suggest an outright lack of agency or power—as an animacy hierarchy might predict—but a particular sexual economy of affect in which the butch's sexual pleasure can emerge from the touch instigated by her, whereas she prefers not to be touched by her lover. The stoneness of butch can also refer to the masculinities of expressive life for butches: feelings held in, the appearance of unfeeling. 'Being stone' is thus not merely a queer affect; it also tugs at and traverses the animacy hierarchy's affective economy with regard to both feeling and touch.*

For some time things have been difficult with your partner. In large part this is because you occupy entirely different temporalities: they move too quickly, you move too slowly. You don't need

15

to walk so slowly, they say impatiently. You need space and time to think and they need immediate answers. They live in the city and you live with the stones, and so your external worlds run on different temporalities, too. And they exist solely in the present, whereas you attempt to occupy and predict the future, rendering the unknowable tame and somehow manageable. You are back in the city, though, here to attempt to reconcile, a project that requires slowness and thought but feels urgent and frantic. Alone, you walk down the street to their house. You are looking for small stones. High-rise apartment blocks are growing faster than weeds, here. Where is the earth, you mutter. Concrete slabs, broken up by small patches of soil from which a young tree grows awkwardly. Tarmac, more tarmac, more concrete, a small patch of yellowing grass. The only stone you can see is on the gleaming entrances to newly built blocks of flats. The small fossils splattered across polished slabs of limestone are a prized asset, an expensive ornament. They died, billions of years ago, so that this block of flats, this housing as bullion, could be built.

> *Luce Irigaray: Fencing in our natures,*
> *turning our bodies into private proper-*
> *ties or ready-made homes.*

You take out a small chisel and a hammer, and begin to chip away around the outline of one of the fossils. It is tough work, small chips fly at you, it does not want to be severed. Eventually it falls into your hand, though, rough-hewn with one impossibly flat surface. You have rescued it. But you keep chiselling, until a small crack appears across the slab, and you keep chiselling, and the crack becomes larger. You walk away, putting the lump of building, the living creature, in your pocket. Some time later the building softly collapses, crumbling to its foundations, cloud of dust blooming outwards. Sometimes you must operate faster than stone.

> *@pisshets: If you add two pounds of*
> *sugar to literally one ton of concrete*
> *it will ruin the concrete and make*
> *it unable to set properly which is good*
> *to know if you wanna resist something*
> *being built, French anarchists used*
> *this to resist prison construction in*
> *the 80s*

16

It is crushing that the love of your life may not feel the same urgent tug towards you. It is crushing that you are not the love of their life. You lie in bed and tell yourself they are singular to you, you are one of a series to them. It can't be helped, it's no one's fault. This is why you left, probably, even though you feel pulled towards them. Desire moves you, towards people, towards beings, towards things, towards goals, towards tasks, towards places. This is the Love Empedocles describes: not a desire for reproduction, but a desire simply for touch, and pleasure, and being together, and understanding each other so deeply, in close contact.

> *Audre Lorde: In touch with the erotic,*
> *I become less willing to accept power-*
> *lessness, or those other supplied states*
> *of being which are not native to me,*
> *such as resignation, despair, self-*
> *effacement, depression, self-denial.*
> *And yes, there is a hierarchy.*
> *There is a difference between painting*
> *a back fence and writing a poem, but*
> *only one of quantity. And there is,*
> *for me, no difference between writing*
> *a good poem and moving into sunlight*
> *against the body of a woman I love.*

You saw Love as an act of belonging and they saw Love as an act of escape. You move between Love and Strife, between intense desire and deep hatred. Misunderstanding, hurt pride, the compulsion to rush what cannot be rushed. You have sought out Love as an act of rooting yourself, of embedding yourself within the world. Whether that Love is between you and them, between you and the rocks, between you and the neighbour's cat who visited you daily, between you and your friends who are your soulmates and your family. Love is a way of saying I matter, and I am matter, I am in community, I belong. For them, Love has offered a line of flight from the oppressiveness of the world. Matter pressing in on them from all sides, an unbearable weight, they have sought to evaporate.

Your body goals are a limestone cliff, their body goals are diaphanous wisps of nimbus clouds.

In Middle English, a cliff is a clud of ston, a cloud of stone. The same beings, different temporalities.

It is only when you are so close that you cannot see someone as a separate whole, that you cannot attempt to form a cohesive idea of them, that you can begin to understand each

other. It is only when you are so close that you can see every pore and their smell is your air, in the space of not knowing, you understand. Years ago, apropos of nothing, you wrote a note to yourself: touch is the original language. This note floats to the surface of your mind again. Touch is the original language.

There are approximately 135 billion neurons across one human body, with two thirds concentrated in the brain. An octopus has on average 500 million neurons across its body, but two thirds of these are in its limbs. The arms of an octopus have their own sensors, can control themselves without relaying information to the brain. An octopus nervous system is a hybrid of central and localised knowledge. What would a body of different localised knowledges look like: arms seeking food, seeking sensation, seeking pleasure, independent of a centrally organised, singular I.

You do not understand if pleasure is located at the site of touch, or in the brain. Sensory information is sent there; processing takes place; instructions, both conscious and unconscious, issue forth. Everything is mediated and moderated by your head, you have been told. In Western metaphors for the body as social group, the head is always the boss (of the family, the company, the nation-state) – it serves colonial powers to believe that power must be organised centrally. The head is all-powerful, and crucially, the head is right at the centre, a structure based on a core fed by a periphery.

Disembodied arms have no eyes to see. They cannot sense other beings at a distance, there is only touch. Their pleasure is not fed back to a higher being, they are beings in themselves. Your arm, caressing the limestone. What if your arm does not perceive this interaction as running your skin along limestone, a type of rock to be taxonomically organised, but instead as a singular encounter between two beings, who are both unique and unable to be quantified. You begin to lose yourself in the rough bumps and patches of lichen that populate the surface, in the persistent coldness, the occasional jagged edge. A woodlouse, or some other invertebrate, is crawling across your index finger, you can feel it. You don't mind, sometimes it's nice to have a third. The woodlouse falls off, or steps off, your hand, and it is just you and the rock, you and the countless billions of marine invertebrates who came together to make this encounter. You are not alone. Remind yourself: you are not alone.

Empedocles: Love.
Clinging Love.

18

our souls are woven together across time
i said to you
on my birthday when
hyped up on love for each other we
hugged in your living room and
you asked me confused
our assholes are woven together across time
and
this
we knew
to be truer than
the initial statement.
we love fully from our mawe we ken
a love so deep it sometimes makes me - -
guts woven together microbiomes small universes of emotions
 and bacteria and intergenerational trauma and inflammation
 and love bound together across centuries
peristaltic ileums intertwined
universes of bacteria moving squeezing contracting pulsing with
 each other
guts that love eggs and garlicky greens and yoghurt brined
 chicken and falling in love with the wrong people
 garlic gives me the worst bloating gas and yet I
 cannot stop
taking another serving of buttery wilted spinach and
paying for it later
why does my mouth want what my guts cannot handle and why
 does it taste so good
i ask you
handing back the bowl
why are we drawn to the things that are bad for us

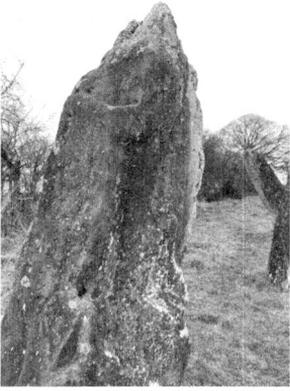

1.94

I do not react well to the nightshade family. Face and mawe swell and tighten to a point of pain, and I remind myself: do not ete tomatoe, do not ete potatoe, do not ete aubergine, do not ete pepper, and yet still Iyam drawn to these plants, I want of them, I lust for them.

There was a time when I would ete almost nothing save tomatoe. I would consume, of a day, two pounds of the blede. This would not be in one sitting: no, for I would, throughout the day, ete on, two, thre, a gentle snack. The thought would occur: a tomatoe. This thought then would build in the mind, till I could no longer suppress itt, and I would go, ete, graze throughout the day. I did not observe mealtimes, there were no meals, there were only these foul fruit. And do yew know, since then Iyam unable to ingest them, an intolerance born through oversaturacioun.

Today I ete tomatoe with salt, and the mawe hardens, itt bloats outwards. Itt is difficult to concentrate, so discomforted Iyam. Clothing is impossibly constricted. I boil duckweed in goat's milk, and bathe the warm lotion on the stomak intermittently throughout the day. And I do curse myself, for my weiknes.

1.103

I fear constipacioun above all other ailments. I have not passed stool in thre days, and fele no urge to. Itt is no drede: excrement piles up in the colon, slowly hardening into a rock. Feling the creaking stasis of the gut, I boil duckweed in a pot, then cast itt into a pan, and fry itt with a quantity of blood and butter. This I ete hot, and await itts effects.

1.109

The constipacioun is still felt. Five days with no stool and no abdominal cramping; drinche I greet amounts of fluid to no avail. Do yew know I astound myself with the quantity of fluid I can ingest. Some years prior to this day, I would take no food save six whites of eggs at eventide. A hunger followed me everywhere,

from morning until sleep. At this time, around midday, itt was my particular wish to sit and drinche two pints of hot fluid within the space of an hour, and then repeat this operacioun at dusk. Itt warmed me, when the flesh was unable to warm itself, and itt filled me, when I was not filling myself.

On this day, I ingest similar greet quantities of liquid, though in a less concentrated time, instead staggering my intake as sips, across the hours of daylight. Still, this does not ease the stasis: rather itt seems to contribute to itt, sitting like a lake atop the sticky, compacted mud lining the intestines. Nothing moves. Thus I take salt and second milk in equal parts. These I place on the fire in an evaporating dish, until itt has reduced into a congealed, waxy mass. From this unguent I make suppository cakes and insert one into the rectum, to await its effect.

1.117

Surfet. I cannot quite explain why I have frequent lyke to ete so much that I fele quite nauseous. This urge takes over approximately every other day, and I often will ete to the point of extreme distentioun of the mawe, then purge the contents violently. To inflate then deflate: I need this sensacioun. This eventide I ete seven bananas and fele extremely sicke, and yet the bananas will not rise through the oesophagus: I cannot purge them. This is abhorrent: the inability to purge is the absolute worst fear of one who will purge.

Itt had been that on Sunnenday, I would ete greet quantity of banana and porridge, then, a mere two houres later, a greet quantity of salmon and wheaten bred, swiftly followed by greet quantity of chocolate brownie and raspberrie, and make myself quite ill throughout Monenday. It was only when I was prescribed the contraceptive pill and the appetite increased quite fourfold that I desired to ete this amount and more, every day, and I knew the flesh would fatten if the appetite gain'd maistry. Lo, apprehend I a violent methodology of purging. Itt is not a prescriptioun I would recommend or share with yew. This eventide, though, itt does prove ineffectual, and the bananas remain stuck. I let them be, I digest them, much as I loathe digestioun.

I take a turnip and boil it in goat milk, and take gentle sips until the stomak is quelled.

The bowels will not loosen, thei are obstinately firm and static. Iyam quite at the end of my tether, knowing that I must continue eten in order to promote peristalsis, and yet not wishing to add to the compounding mass of shit accruing in the mawe. When I lie on my bed, I can fele a thick rope of excrement extending up the transverse colon.

Thistles as the thistles on the enamell'd broche my mother would wear, the purple tarnish'd and scuffed. I remember not herr wearing this broche, I only remember itt sitting in herr jewellery box, and should I chance to remove itt, sche would find it in the hand and sche would tell me: this is the first piece of jewellery yr father did buy for me. I boil the roots of small thistles that grow in the woods, these roots of thistles I boil in water, this water I drinche with relish.

Iyam uncertain if I have had an inflammatory response to the nightshade, or if I have gained fat on my flesh, but I will tell yew that I gained quite 4 pounds overnight, much to my disgust. This flesh is repellent to me. I have begun drinchen the juice of fennel.

I try to restrain the appetite, for I must curb these urges toward surfet. Fayne would I live long, and a cycle of bingeing and purging may cut short my years without consent. I have heard that ongoing irritatioun of the throat may cause a canker, or still a rupture through the oesophagus into the flesh beyond. I do not wish for dethe, or to have my dethe discussed in papers and on websites in lascivious terms. My greet fear is autopsy, my greet fear is to have the contents of the bowel pored over and discussed, my greet fear is that I should be defined by a base and shameful dethe, a dethe by overeting, a dethe that would be discussed with disgust. And so I shall restrain the appetite, and ete slowly. I shall not ingest to the point of distentioun. This too may aid in evacuacioun. The irregularity of the bowels is troubling to me: I must work towards a daily evacuacioun of substantial volume.

Trowe that this lust for fullness is a moral impunity and might represent something sexual. Trowe that I wish to reach a crescendo of food like the crescendo of balsamic injectioun. Iyam attempting eten and to allow some appetite to remain. Today, I ete sparingly, allowing myself to maintain a sense of hunger even after each repast. I drinche nothing with my meal, and throughout the day I drinche sparingly, choosing only the coldest water I can obtain. After eten, I take a brief walk in well-sheltered and level ground.

Tonight I shall sleep well, but not too much. I must give pause between my meal of eventide and my bed, for itt is known that sleep before food will make a body thin, while sleeping after will make one fat.

These shall be the rules moving forward:

- Ete two small meals each day, to remain hungry after the meal has passed.
- Drinche nothing with each meal.
- Sippe only little throughout the day, from the coldest source I might obtain.
- Forbede these chemical sweteners which I will use to make drynk more palatable: I fear thei aggravate the mawe.
- Do make enough time between meals that I might fele empty: this I shall sense from my hunger and the thinness of my saliva.
- Sleep, some time after my final repast, deeply, but not for too long.

2.22

When I go to toilet, I pass only tiny pebbles, after much straining, and little else emerges. Itt does not represent my daily intake and I fear that if I do not pass a substantial stool soon, the thick and unwieldy serpent of shit in the colon will begin to extend into the small intestine. There is, happily, approximately 25 feet of this organ for itt to traverse before it might creep into the mawe, but if nothing happens then perhaps, in a year, I will begin spiwan excrement.

When I would take pills derived from the leaves of the senna plant, I would never experience this aggregate of shit. To my infinite earthly delight, there would be a direct correlacioun between input and output: I might ete my one meal of the day at eventide, then after a good sleep of eight houre, I would evacuate a liquid in which the foods were suspended, barely digested.

Sooth, this time was a time of much pain to me, much sicknesse. Fayne I shall never revisit itt, but still I sometimes wish I could be this empty again. These tiny peblles I pass on toilet, these peblles are mere chips in the enormous boulder residing in the rectum, a compounding of any number of meals of the days prior. I must chip away at the boulder by eten. Must I ete foods that are medicinals, medicinals that are foods, much as I fear that these foods will not be curie. Warily do I take a newly laid hen's egg and remove the white. Into the shell, I scoop unsalted butter to mix with the yolk, until the shell is full. This I warm, then ete. Itt sits well, but I do not shit. These eggs shall become a regular part of my regimen until I fele colonic spasming.

2.96

I cannot express to yew my discomfort. I fele now a spasming, and excrement begins to emerge, but itt has hardened to a point that itt is impossible to pass through the rectum, and so itt gives me pain.

I take a pennyworth of stibium and grate itt as fine as flour, though this process gives me grief, for metal will take some time to grate, even one so soft as stibium – or antimony as yew may call itt. This powder I mix with a pint of sound ale, and warm. I ete nothing in the morning, and drinche only this liquid.

Quite half the houre has passed when a quart of posset do I drinche: I thence proceed drinche again, and once more for good measure – this as instructed. Later, I warm spring water, put some good butter and honey into it, and drinche the draught in two sittings. This consists my day.

2.97

When I ended my regimen of senna laxative, I was quite seekly. The recovree was slow, though I did visit a beach upon whose sandy edges plenty bushes of buckthorn grew. I harvested the berries, and these I keep in the freezer for such times as the present. For today the entire gut is static, and I seek the mollificaccioun of the rock

of shit. So I express the juice of buckthorn and mixe two spoon-fuls with a draught of good ale wort. This drinche I, and await its effects, willing the bowels to loosen. Still thei remain obstinate, still thei remain static. Thusly I drinche another draught without the buckthorn. I manage to force out a thin, tapering worm of soft excrement, perhaps passed through the spaces around the hard-ened ston lodged in the rectum, and so I ete some warm oatmeal gruel made with spring water, mixing it with some honey, butter, and unsifted wheaten bred.

Over the next nin days I shall follow this regimen thrice. I hope that the tapering worm shall grow to a fattened, thick and muscular snake, which coils out of the rectum and lands in the toilet bowl like a triumphant best. If the best does not make itts presence known, I shall lead a further nin days on milk food and wheaten bred.

2.98

The abdomen is distended. I take a handful of the leaves of dam-ask roses, boil them in the wort of good ale, and this I drinche. I shalt follow a regimen of milk food and wheaten bred for a further nin days.

2.99

Today I have result. After some straining for quite thritti minuten, I manage to dislodge a plug of hardened shit the shape of a bulb of garlic. This is followed by a fat, soft rope quite two inches in diam-eter, and my relief is indescribable. I shall tell yew how I gained maistry over the gut.

Two days prior I took honey, and the juice of the fruit of buckthorn, in equal quantity. I boiled these together over a slow heat, and kept in a well-covered glass bottle. Today I take thre spoonfuls of this liquid. Thritti minuten after, I drinche a hearty draught of the wort of strong ale. Itt is not another thritti minuten until I fele colonic spasming, a dearly belov'd friend from a distant past. Sitting on toilet, the pain of passing the bulbous plug is quite extreme, such that I worrie I should tear the rectum, but I do not. I have only enough time to turn and observe its form in the water: bitymes it is proceeded by a soft and warm evacua-cioun of what must be almost the full contents of the descending colon. My solas is greet.

I have been experiencing a humoral flatulence which has been weakening both body and mind. My mother once told me: I do not pass wind. Sche instilled in us a belief that to pass wind was a moral failing, and a failing of femininity in addicioun. But in this latter endeavour I wish to fail, and so often I fert freely and with relish. And I shall die, all peacefully pickled in ferts.

This flatuelence, though, it brings me agonie. And so this morning, before breaking my fast, I take the juice of swete apples, raspberries, plums and blackberries, strained. I set it upon a slow fire, and add a spoon of honey for every draught, bringing the liquid to a gentle boil. I shall drinche a hearty draught of this with my morning meal, and for the next nin days hence shall ete only bred made from highly roasted akorns. My supply of akorns is low, perhaps only enough for two lof. Should I not be able to obtain more in the nin day period, I shall not worry. Many nettles grow by the roots of the swete apple tres, and these I shall pull up from the ground, dry the roots away from the fire, and grind to a powder to make bred.

2.107

Flatulence does not diminish or abate. I cannot pass an houre without emitting a violent and noxious gas. There is no one else to witness the event, so I fele no shame, but I do fele a perpetual discomfort at the tautened mawe, filled with a toxic air. Offen it is swete agonie.

I take a spoonful of mustard seed this morning, then again at midday, washed down with good old mead. I shall repeat this dosage again tonight, and tomorwe I shall begin a regimen of milk diet and well-baked wheaten bred, eting small amounts at regular intervals.

2.161

Abdominal distentioun has increased. I have eten no nightshades, no aggravating fods, and yet it continues to swell like a drum. It is eventide. I have eten nothing all day. This is not rare: eten during daylight is more the rarity. I find Iyam unable to concentrate after fod or drynk, and so I fast throughout the daylight houres and will only ete once the sun is set. Today, I take two spoonfuls of the juice

of holly. Tomorwe I drinche it thrice, at intervals throughout the day, and continue for nin days.

2.198

Distentioun has decreased, though occasional cramps do hinder my daily activities. I take a little tansy and reduce itt to a fine powder. This I take with white wine to remove the pain.

2.199

I take some tansy and southernwood, boile together and ete well with salt. I ete nothing else this day. Agonies across the mawe continue to attend me.

2.649

Again Iyam met by the unruly swelling of the stomak, extending beyond the waistband of my denim. I must loosen my jean, and walk around my home with unbuttoned trouser. In such a state of discomfort, I take the roots of fennel and the roots of ash, and pound well, tempering with wine and honey. The expressed liquor shall be my drynk from now until the day is closed.

2.749

Gastrodynnia. I take mugwort, plaintain and red nettle. This I boil in goat's whey, strained through linen, and administer to myself.

2.762

I return to a stagnacioun of the colon. Thus I take small beer, unsalted butter, and wheat bran, boil well and strain. This I pour into a bladdre, into which I insert a quill, then tye up the bladdre around it. This quill I pass gently into the rectum, the hed being lower than the pelvis, and I force the fluid into the body, then right myself as quickly as possible. Results follow quickly, though only a small amount of shit produced, and what pours out of me is mostly what I pour'd in.

I worry that my pains indicate a wider illness, perhaps a sicknesse more serious than distempers. Wary am I to admit true sicknesse: my dethe is something unfathomable to me, a thing impossible, a thing that may never pass. I do not seek diagnosis, I will axe no one else, no one might know, but tonight before bed I shall bruise violets and apply them to the eie-brous. If I slepe I shall live, and if not my fate is sealed.

en
od,
e,
pe
ix,
u=
re
m.
ati
:fu
&
am
no=
ra
et
:o=
l res terrenas respectum;fexum

The human:
No, I'm not. It's just. I'm in the bath. Please can I just, can I have a minute.

The swan:
Lift me in.

The human:
No.

The swan:
Lift me in.

The human:
No.

The swan:
It is imperative that you lift me in.

The human:
Oh is it.

The swan:
Yes, it is.

The human:
The last time. Look I just. I don't want to swim in yr shit. again.

The swan:
That was not the last time, it was one time on I believe it was the twenty-first of March and you know that when I'm aroused I sometimes pass all manner of liquids, on the subject of which, you are keenly aware that I do not produce a discrete and separate object that you would call a shit, it is

The human:
Ok fine, I just don't want to be swimming in yr ass effusions, then.

The swan:
As you also should be aware, I also do not have an anus, I would hope that one so intimately familiar with my body would be aware of the specificities of my orifyces, now I insist that you let me in to this delicious warm puddle filled with yr divine naked form.

The human:
Right. Well. I was about to get out, so

The swan:
Stay but a while, I would drown in you.

The human:
Well I'm kind of. I have a presentation to finish for tomorrow so
Oh no, don't drink that.
Don't, it's got bubble bath, and like, bits of my dirt,
you know.

The swan:
I know, it is why I drink, you are delicious and perfect in every way, I would drown in you, permit me to say but

The human:
Ok but it's just. It's just a, a hot soup of my skin and dirt. I don't think you should. And I don't know about the safety of eating soap, it's
Ok stop.

Don't drink it. I'm serious.

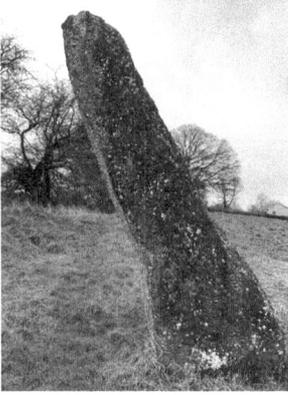

Celidonie is a ston þat men fynd in þe wombe of a swallow. Sche is not feyr, but not for þen she is Moche valowur & mor þen eny oþer stons in profyte. Of þes stons þer ben too maneres; þer bene þe one blake & þat oþer red; þe red is god aȝens a malady þat men clepen lunatix, wherby he falleþ, & wherby he is foolych & wytles & falleþ þer-wth long-tyme; let him ber þis ston & it will make him well to spek & wel to be loued and syde. But þe blak ston, & a man bere it in such maner, it schal help to do grete þynges. It helpeþ aȝens malices of gret princes & kynges. Þe water þat it is wasshen in is myche worþe to hot yueles. Also it is miche worþ þis ston, if it be hold at þe sacrament & he wounden in linen cloþe, withholdeþ þe feuer & aȝen stondeþ wycked humours þat comen abowte in many maners; and if it be wasshen & if ben in clen water it is gode for sor yene.

The Peterborough Lapidary

Celidony is a ston which men find in the womb of a swallow. She is not beautiful, but nevertheless she is of much value and more profitable than any other ston. There are two kinds of these stons; there is one black and another red. The red is good against a malady which men call lunacy, in which a man stumbles, and in which he is foolish and without judgement and suffers from this for a long time. Let him bear this ston and it will make him speak well and to be well loved. But if a man bears the black ston in this way, it will help him do great things. It helps against malice of great princes and kings. The water it is washed in is of much value to hot evils. Also this ston is very valuable if it is held up at the sacrament and is wound in a linen cloth; it withholds the fever and withstands wicked humours that come about in many ways, and if it is washed in pure water it is good for sore eyes.

I don't remember how old I was, all I remember was that I was a kid, a child, definitely not a teenager yet, still a child. And listen, I know this because I still had a really simple, I don't know, an easy relationship with my body and food. With some people I know these relationships become muddied earlier, but for me, at least, it wasn't until I was twelve or thirteen that I began to, I don't know, before I realised the connection between what I ate and er, its impact on my flesh, I guess.

So before all that. I don't know how it happened, or how I let it happen, but somehow I became incredibly constipated. Not in the way that, it's not like I felt none of that spasming:

trust me, that sensation did not go away at all. And I was passing matter: just a thin, mucosal drool. Because you see what had happened was that there was a plug of hardened matter lodged in my rectum, which meant that whenever I sat on the toilet, I was straining and all that, and it felt as though my asshole was about to tear, and so I would stop, and my guts would still be telling me to push, but the fear of pain, of just, thinking I would rip open, well all that was telling me to stop. Holding it in was also causing serious, major discomfort. I was staying at my grandparents' house at the time, because you see my parents both worked so in the summer holidays we would go and stay with them. So, I spent two or three days rolling around in bed in pain, and also I was lining my underwear with loads of loo roll because see, all this watery shit was coming out of my ass all the time, trying to force its way out. And my grandma started complaining loudly about the toilet roll being used too much, because she didn't know what was going on, I hadn't told anyone, she kept saying somebody is using all the toilet roll up, and when she started complaining like this I thought well, I can't tell her now, because then that will also be owning up to being that somebody using all the loo roll, so then there was this whole layer of shame added to the proceedings.

Anyway, it was awful. I mean, I don't have that many vivid memories of childhood, mostly just snatches and glimpses you know, but this, this I remember vividly. It's funny, isn't it. When you're an adult, what constitutes a traumatic event is something major, some catastrophe or act of extreme violence. But when you're a kid, you can be screwed up by, I mean you can originate your own trauma just by not going to the toilet regularly enough.

So the long and short of it is, at some point I pushed through the pain and I didn't tear my rectum, thank christ, I just passed this weird garlic-bulb-shaped thing and it was all over. But when I turned around to look in the toilet bowl, it was wild, because I could see there were bits of it that looked red. Really bright red, too, enough to make me notice, not in a fleshy bloody sort of way, it was more, I don't know it was just more. So, swear to god, I picked it up out of the toilet, which, now I think about it, is pretty gross. But I picked it up, I got some toilet roll bunched up and I plunged my hand into the water in the bowl, because I realised that there was hardened shit crusted around something else, it was like, a stone. A big stone, about a centimetre, centimetre and a half maybe? You know it reminded me of the unpolished crystals that my grandpa had in these funny little clear plastic boxes, with labels on them, and it looked like amethyst in shape, and it was also glassy, but it was definitely not amethyst, because

it was bright red, but like I say, not blood and viscera red. No, it was more ruby, jewel, you know, like the colour of raspberry jelly.

Anyway I bet you're wondering what I did with it. Well, being the gross little kid that I was, I rinsed it in the sink, and I kept it. I had it for years you know, it was my lucky charm, and if I was ever constipated or if I ever had any bowel issues at all, I would just put it under my pillow and they would go away. And it was a cool thing to have, I used to say to my friends, you know, I gave birth to this stone, I produced it. But do I have it now? No, no, sadly. I don't. It was one of those things, you know, you move house, and somehow in all the chaos things get lost. But it's got to be somewhere, in the universe. I hope that whoever has it now has regular bowels, you know?

I wante
to fucke
the see and
forsopie

I want
to fuck
the sea and
dissolve

i wante to be the mist hitten the face of a hyker in the brecon becons / i wante to go doun the urethrill chanell of a gote, & up the xylemm of a wodie stemme pelargonyum / i longe to be the vernish of muciss on the skin of a slug, the jelly-lyke sak of bakteryal cytoplasum / i wante to find mineself in the pittd bordels of the endoplasumec rityculum of a nerue celle, som-where along the legg of an instagram influencer / to be part of the nile / to be an egge, boilen in a pote of bobelen me / i longe to be the snou totrodden under-fote on mount kita / to be the caustik, vapouring bobels in the botel of mountain dew / this be profounde lustfulnesse, an unendeable orgasum I treuli longe
[...]

I want to be the mist hitting the face of a hiker in the brecon beacons / I want to travel down the urethral channel of a goat, and up the xylem of a woody stemmed pelargonium / I long to be the sheen of mucus on the skin of a slug, the jelly-like sac of bacterial cytoplasm / i want to find myself in the pitted edges of the endoplasmic reticulum of a nerve cell, somewhere along the leg of an instagram influencer / to be part of the Nile / to be an egg, boiled in a pot of bubbling me / I long to be the snow trodden underfoot on Mount Kita / to be the caustic, evaporating bubbles in the bottle of Mountain Dew / this is a profound desire, an unending orgasm I truly want
[...]

During a season of great mortality,
With pestilence reigning, and other disease,
I felt a great urge to change my locality—
To go as a pilgrim, my conscience to ease—
And left for the country as quick as you please.
'A Disputacioun Betwyx the Body and Wormes'

Enter Body.
It is wearing tartan pyjama trousers,
a T-shirt (clean but stained), yellow
pool sliders and white socks.

Every day it wakes up and it is the same
objects around it do not move
sometimes the Outside attempts invasion
– phone vibrates and is thrown to the side
the things around the Body are stable unchanging
there was a time when its life was rich with people and now
and now
it is rich with unchanging objects,
during a season of great mortality,
it left for the country as quick as you please.
isolation presents no threat to it
isolation is safety stability
isolation is an unchanging state, the Body does not need people
and people are not safe
safety comes from the objects around it
from brief interactions with no wants or needs
it must
stop
replying to people
move further away from them
geography is the clearest []
and make a routine that will give it []

keep your solitude

it looks forward to its evening meal that it eats in silence
finding pleasure in the small things that it can vary

43

an egg with a golden yolk
different salt
the Body must not miss people, it is hard to be wanted
to be needed is something it has not experienced
keep everything clean and everything ordered
this is a story about removing all want

The way out is solitude

*A hot summer. The Body forgets to take
the bins out. A black bin bag sits in a
corner for three weeks, slowly rotting.
The wormes enter the room.*

wanting to want again
Wormes, wormes,
the wormes tell the Body: glutinous pleasure
the wormes are reminding it all is not dead
we find that we possess exactly what we desire
a bin bag splits, erupts with a cascade of fetid matter a
waterfall of squirming life
they are doing god's work, they say. they are doing god's work.
the things that lie beyond its control:
this is god's work.
it is in stasis, yet time still passes:
this is god's work.
everything grows, ages and dies, everything eats until it is eaten,
 the endless rebirth of flesh and matter:
this, too, is god's work.
the wormes are doing god's work.

*The Body looks intently at the
wriggling mass of wormes who are
starting to spread into the room.*

it had not planned for this.
the Body speaks to the wormes:
wormes, wormes,
why do you do thus? what makes you eat?
i am searching for permanence of flesh and
unchangeability of matter
i am searching for control of our surroundings and
i did not choose you i did not want this
why do you do thus? what makes you eat?

44

i want a world stripped of purpose
no
i want a world stripped of change
i want
i want
and it is in this wanting i seek to shed other forms of wanting
if we go down into ourselves, we find that we possess exactly
 what we desire
a world without love
no love no intimacy no laughter no pain no change no loss
 no grief no contingency no friends no lovers no family no
 people no love

Using a small dustpan and brush, the
Body sweeps up the wormes who spilled
from the bin bag and tips them into an
orange Sainsbury's plastic bag.

the wormes speak to the body:
ye ar filthie
you are just flesh, a bag of fleshy feelings, meat on a mineral
 scaffold
eating and being eaten belong to the terrible secret of love
we come together in love, and are desired by one another.
Not everyone will get it, though
we're not against the body:
there is flesch, there is bits of flesch
a thin, mucosal drool,
words made flesh, muscle and bone animated by hope and desire
when they are in strife all these are different in form and
 separated
we play our part in this we
do god's work
break down and pull apart

The Body responds to the wormes:
the love and strife, that sounds like Empedocles.

Yes, the wormes reply, we ate him.
all the people who were alive, who had ever been alive.
we want to eat everything in sight
for we have been ere now a boy and a girl, a bush and a bird and
 a dumb fish in the sea.

Ten to fifteen wormes stick to the
brush hairs. Some have been crushed
or bisected.
The Body looks at the brush it has used
to sweep up the wormes.
The Body throws the brush into the bag
with the maggots and rotten waste.
The Body pours bleach into the bag.
The Body walks to the back door, opens
it, and places the plastic bag outside.

the wormes are pissed off.

the wormes wait offstage

the wormes observe it creating a story
the wormes observe it narrating its pain
the wormes observe it listening to the soundtracks of sad films
 about lesbians

the wormes wait offstage

the wormes wait offstage

Two years pass.
the wormes wait offstage

The Body enters the room. It is dressed
in a red-and-white tartan pleated skirt,
a black hoodie and black heeled boots
with thick tread.

the body speaks to the wormes:
We have been thinking about pain, wormes
the types we expected and the types we did not
can you tell us a story about
where it hurts,
wormes, wormes,
we need the narrative arc

the wormes reply that it is not that easy
the wormes speak to the Body:
dearest heart,
we cannot calcify the present without killing it
a deadening rigidity, a calcification, a sort of carapace.
it's all beyond control,
so abject:
the insistence of the world in its alterity, exigency, and
 unpredictability.

 [Offstage] The Body's landlord
 poisons a rat which has been occupying
 the outside bins.

we're hungry.
from the earth issue forth things close-pressed and solid
glistening and libidinous rocks:
is our strength the strength of stones?
we are [all] moving towards the lithic,
always tasten, always eten, always absorben .
all the people who were alive, who had ever been alive.
we play our part,
we're so fucken hungry.
everyone in love is oriented towards this absorption.

 The Body goes away for a month.
 Exit Body

the wormes are looking for some Body to eat
the wormes are hungry

 The Rat comes inside and
 crawls into the wall of the downstairs
 toilet to die.
 Enter Rat
 Enter wormes

it arrives home to a wriggling mass under every surface
issuing forth from the walls of the bathroom.
wormes seeking darkness, wormes seeking flesch
wormes under bins and under door mats and under books and
 under printer computer under bags of flour and boxes of
 teabags
plant pots furniture everywhere wormes

the wormes speak to the Body:
you have to leave
You are just flesh, a bag of fleshy feelings
desire moves you, towards people, towards beings, towards
 things, towards goals, towards tasks, towards places
an oily, green-black line of putrescence,
you have to leave
wormes spill out of new balance trainers
the Body speaks to the wormes:
wormes, wormes, i want to rest
why can i not rest
i'm so fucken tired wormes
why can i not rest
You have me for lunch and for supper at night,
now gnawing and eating me right to the bone
with a greedy, insatiable appetite.
there's no rest, for always you suck and bite.

The Body retrieves a red Henry Hoover
from the under-stairs cupboard and
begins to hoover up the wormes.

the wormes speak to the Body:
it is unclear if this is our fault:
you have to keep moving, you cannot stop, you cannot rest.
we tell you this now,
You've had worms in your hands and fleas in your bed
Or lice or nits in your hair each day,
Also stomach-worms to plague you in every way,
And venomous creatures, night and morning,
To make you ready and give you warning.
you have to keep moving, you cannot stop, you cannot rest
you have to keep moving, you cannot stop, you cannot rest
you cannot stop, you cannot rest
you cannot stop, you

Exit wormes

the wormes are pissed off.

Philadelphia

I have given a name to my pain and call it 'dog'.
Nietzsche, *The Gay Science*

We both deserve to be happy
We both deserve to be happy
We both deserve to be happy

I chant this rhythmically as I press into your tongue, willing myself
to feel pleasure, willing myself to feel pleasured, but it does not
work. I must be dead inside, I say, as I stand up abruptly and pull
my underwear up from around my knees. Black cotton, an annoy-
ing frill around the edges, greying gusset. The squelch of cream
cheese against fabric: I cannot believe that I have got to this point.
I must be dead inside.
 I say it for emphasis, for drama, and you back up
on your four legs, looking contrite, then slope out of the bedroom
and back into the kitchen. I say it for emphasis, but I don't think
I mean it, because I don't think I do feel dead inside. To feel dead
inside, I imagine, would be to feel a putrid mound of fetid waste
matter rotting in your core, that spreads like gangrene throughout
the tissues. It would be a definite feeling, and I don't feel like this:
I don't feel anything. I feel completely empty. I think of a tupper-
ware box, fogged plastic, slight red tinge around the seams from
having been washed with tomato-based sauces, but void of con-
tents now. Everything has gone. Feeling has gone. For two months
I have felt precisely nothing.
 You might wonder the parameters of this void, so
I will tell you: this is feeling as in emotion, this is not feeling as
in the sense of touch. When the emptiness began, when I started
feeling this vacuous absence, I wondered how far the numbness
extended. I held my finger over the gas hob for a while to check
that I was still feeling things with my skin. I was. Then I wondered
if physical pain could allow me to access some kind of emotional
response. I thought: I will hold my finger there for a long time, I
will watch it turn vibrant red, watch it swell like a salted slug, wait
for the skin to turn red, to thin, to begin to shine with the pressure
of boiling blood, for a blister to erupt, for the flesh to begin to char,
for thickening blood to begin to pour out then blacken, searing
into sinew and muscle with the heat, I will melt my fat globules

51

and flesh to the bone. But I didn't. Immediately I felt the sting of heat and I withdrew my finger, because I don't like physical pain. I can't stand physical pain. And I didn't feel any emotions, no sadness, or annoyance, or self-pity, or relief that I still had this form of sensation.

My physical feelings and emotional feelings do not exist on a Venn diagram. They are at opposite ends of an axis. I think it is strange that they would share a language.

I wake up, indifferent to the alarm. Getting up fills me neither with horror, nor joy: I do it mechanistically. Nothing is difficult, or easy. It is just a list of things to be done, that must be done. I carry out this list like an automaton. Making coffee is a task, getting dressed is a task, sitting at my desk is a task, texting my friend is a task, writing is a task, sending emails is a task, masturbating is a task, showering is a task, getting into pyjamas is a task, going to bed is a task. Eating is a task. Somewhere in here I also have to care for you, to feed you, take you for walks, stroke your velvety ears: all this is a task. I have been in the stupor of depression before, and there everything felt insurmountable, and everything was the desire to stop, to give in, to sink into the nothingness of pulled-down blinds at 4pm and the comforting smell of my unchanged underwear, and everything was the need to take myself out of a continuum, to stop occupying time. Now, though, I see stasis as neither desirable nor possible. Time continues. To stop fills me with as little desire as to carry on. And so I carry on, but I do so indifferently.

You are different, though. You wake up early – earlier than me, you wake up with the sun, and you bound into my room and jump on my bed and lick my face, filled with sheer joy at the prospect of breakfast. After you have eaten breakfast, you bound over to me filled with the sheer excitement at the prospect of going for a walk, or just of being alive. God knows. This joy is exhausting. I would feel annoyed, except – as previously discussed – I can't feel anything.

I want to want, and I want to feel pleasure. I want to be consumed by feeling, I want to be overwhelmed by it. I press my finger persistently on my urethra, and I feel it, but it is nothing more than the dull recognition of flesh pressing on flesh, no warm orange triangular sensation when I press my palm flat across my crotch and press upwards, squeezing buttocks into my hand. I remember what pleasure felt like, but I do not feel it. When I was twelve I came down with a severe flu that left me with no sense of taste for seven months afterwards. I chewed foods which delivered the same texture, emptied of taste: the fudgy salinic crunch of

cheddar without the astringent tang; the soft yield of raspberries without the sharp freshness; the chewy wadding doughiness of a chelsea bun without the cinnamon sweetness. For seven months it was like I was eating simulacra, props of food, polystyrene. Everything now is polystyrene.

One evening you are sad, for no external reason, and you idle over to where I sit at my desk. You flop your head on my lap, leaden, every movement an inexorable slog against gravity. Big dumb eyes stare up at me. Deep, dark brown, so dark it is impossible to distinguish the iris from the pupil, no white at all, and a rim of black on the surrounding flesh, almost as though you are wearing kohl, though I know you are not wearing kohl. A gummy string of sleepy mucus is always in the corner of your eye, and I always want to pick it out. When I was seven and I saw that juicy, thick crust of snot around Fiona's nostril and I picked it off and I was told, people don't do that, we don't do that. I recently saw a mother pick her own child's nose and then eat it. Whenever I watch you try to scratch your eye yourself it terrifies me: poor coordination, thick, keratinous claws lunging clumsily to carry out microsurgery, so I pull the fatty tail of sleep away myself, and rub it between my fingers. As though it would disappear that way, but it doesn't disappear: my fingers are slightly sticky, but I don't want to move to clean them, because you look so comfortable, so pathetically comfortable, big dumb eyes and big dumb snout resting on my lap. Your flat tongue protrudes slightly, I offer you my fingers, your mucus, and you lick it off. You have always felt things so deeply, I say.

Since I have become tupperware, or since I have begun to live in this polystyrene world – but perhaps I need to arrange these metaphors better, though what is persistent throughout is the plastic impenetrability of the boundary between myself and everything else – but since I have begun to feel nothing, it seems that you have begun to feel more. I cannot tell if this is simply as the contrast between us is greater, or if you have in fact now started to feel for the both of us. Our senses, after all, are assonant, a residual inheritance of our co-evolution. Your sense of smell makes up for my lack; my superior sight stands in for your deficit. Perhaps this is nothing more than an emotional co-evolution. And so, this evening, when you are so sad and I am so tupperware polystyrene hollow, I think, perhaps we can make each other happy.

Looking into your eyes again I say, how can I make this happen, logistically? Your greatest joy is from food, so of course my natural inclination is to cover myself in edible substances in

order to encourage you to lick. Still sitting at the desk, I look over to the work surface in the kitchen where a half-empty tin of dog food sits, chunks of reconstituted meat slowly curling dry at the upper edges. It is not so much a disgust as a pragmatic concern related to hygiene and my own mucosal membranes that leads me to dismiss this as an option. Chocolate, of course, would also prove toxic – to you this time, rather than me. I mentally run through a checklist of foods in the fridge. Cheese. Cream cheese. That could work, I say out loud again. You look up at me inquisitively, and I nudge your head off my lap.

We both deserve to be happy, I say, walking into the bedroom, Philadelphia in hand, summoning you to walk behind me. Your flat, rough tongue might be my salvation, and I might be yours. This is something familiar, a familiar set piece from fiction. This should represent a slide into desperation or depravity, but it is neither of those things. We are simply two animals who deserve to be happy. I dig my fingers into the tub, scoop out a wad of the cheese. Pubic hairs stringy with pasty white.

We both deserve to be happy
We both deserve to be happy
We both deserve to be happy

But, as previously discussed, it does not work. Nothing has changed. There is cream cheese all over me, cream cheese on the sheets. I give up, get up and follow you into the kitchen, thinking of the steps that must be taken to clean up. I need to wipe myself clean, I need to shower. I need to wipe the sheets clean, I need to strip the bed, wash the sheets and my underwear, put a new fitted sheet on the bed. I need to wipe up the scattered blobs of watery Philadelphia thinned by your saliva and my mucosal fluids, I need to mop the floor. I need to take you for a walk. This is the list of things to be done: I feel nothing.

ye ar filthie
you are filthy
ye craude þe gryme þe drit in þe bordels of þe baþ-roum tiles
 reminden
you crave the grime the dirt in the edges of the bathroom tiles
 reminding
ye al mater is aliue
you all matter is alive
ye teste þe edges of yoreself bi felen þyngs
you test the edges of yourself by feeling things
 allowen yoreself to fele þyngs
 allowing yourself to feel things

see þe gryme in þe bordels of a baþ-roum tyle and reminde
 yoreself it is aliue but it schal nott -
see the grime in the edges of a bathroom tile and remind yourself it is
 alive but it won't –
it is nott a thret to ye
it's not a threat to you

þe desirs of oþer people ar nott a thret to ye
the desires of other people are not a threat to you
an
and
þen
then
þe
the
worlde
world
is opyn
is open
tyme is emptie, tome calde
time is empty, void & *cold*
hwylc is sweteli,
which is nice,
ye þrede
you think
also gromful
also scary

is it
is it

begripen þe sweteli
hold on to the nice
lustin
listen
ye moste lustnin
you must listen
ye moste
you must
reminde yoreself þe wilde bore ye akende runnen pass'd yore car
- nott a bad omin – a gode one
remind yourself the wild boar you witnessed running past your car
– not a bad omen – a good one
 nott methaphoris
 not metaphorical

swich a bigge animale
such a big animal
gallopen slowlie, lollopen, is þat euen þe rihte worde, haha, ye
schal - - -
galloping slowly, lolloping, is that even the right word, haha, you
will - - -

þe heres on its shulders corse tuftes yllumenate bi þe hedlites
the hairs on its shoulders coarse tufts illuminated by the headlights
canne ye nott descriven howe parfit –
you cannot describe how perfect –
lustnin
listen
traume iwintred yore bons & balsamat yore face & ye existe in
mani whyle-mel &
trauma aged your bones and preserved your face and you exist in
many temporalities and
ye moste remembre þis þis þis is also nott methaphoris
you must remember this this this is also not a metaphor

lustnin
listen

þe þyng is, þe reale þyng is,
the thing is, the real thing is,
Peple

People
weder humain or peple eueri-wher. þe standen stons ye visite
whether human or *people everywhere. the standing stones you visit*
daly: also peple
daily: also people

ye moste siten yoreself
you must situate yourself
reminde yoreself
remind yourself
ye moste permetten yoreself
you must allow yourself
ben ymolde bi þe lond
to be shaped by the land
trien nott to molden þe lond
not try to shape the land
ye possesse nott þe
you don't have the
ye kanne,
you know,
no on possesse þe
no one does

þat is wen þe wordes schal com, nott þese wordes, nott wordes
 lyke þese, nott þese
that is when the words will come, not these words, not words
 like these, not these
accustomabel souns and eccoes, naye, eye spelle, languge ymolde
 bi rokkes, semantecks ymade
familiar sounds and echoes, no, i mean, language
 shaped by rocks, semantics formed
bi togederspekinge wiþ a smere of bird shite & a tufte of yellwe
 lychen & mille yeres of stuff & a
by speaking with a smear of bird shit and a tuft of yellow
 lichen and thousands of years of stuff and a
fukken wilde bore, eye swere, yore voys is a macse of yore
 ancestres & þe soles of yore neue
fucking wild boar, I swear, your voice is a mix of your
 ancestors and the soles of your new
balans trayners & kurlyd up scribbels of þe huskes of dessicated
 spithers ye finde in þe corneres
balance trainers and the curled up scribbles of the husks of dessicated
 spiders you find in the corners
of roums & þe shepe ye passe on þe þaþe to þe rokkes

of rooms and the sheep you walk past on the path to the rocks
& & whatsapp messages from dates & fukkes & frends & þat
 assorte ye mene to outfaren
and and whatsapp messages from dates and friends and that
 group you keep meaning to leave
& þe charrd bons of þe pulter fro wen ye unbithouȝt þe
 astor, & þe rokkes, yetten, al-wei, þe
and the charred bones of the chicken from when you forgot about the
 stock, and the rocks, again, always, the
rokkes
rocks
so
so
mani
many
peple
People

eueri-wher
everywhere

a ligne of scome in þe sink-bacin soth-sauen þat
a line of scum in the sink basin tells the truth that
tyme is extendeblie calde,
time is endlessly cold,
hwylc is sweteli, nyce
which is nice, satisfying
ye þrede
you think

holde on-to þe nyce
hold on to the nice

today the pebble shifted slightly
and i could not get out of bed
it grates against my soft lobes still
sometimes i feel it next to my eyes
we dont know how it arrived there
something to do with a raw piece of bacon i ate once
or did i tell you i was dropped on my head as a baby you know
 before my skull had
the soft parts of my crown still pliant open why do they make
 babies like that
no kneecaps A FALSE NOSE FALSE / TEETH FALSE HAIR
 ENAMELLED HANDS FALSE FEET
stone crept in the hole
i was crying in the job centre and asking
why am i ▮▮▮▮▮▮▮▮▮▮▮▮▮▮▮▮▮▮▮▮▮▮▮▮
i want to know why i am broken
shard of flint lodged in my stupid little brain
a natural fool
why am i always falling behind
an ever increasing backlog of emails to send
8 months, i tell you, 8 months is my limit, my giddy limit !!
hold still we can remove it quickly
the time it takes for the flint to orbit my mind
i cannot hold a job for longer than 8 months
another orbit of the skull
solar return of the flint folded into my cerebellum
a curdled milk
help me to remove the stone
master,
cut the stone out, fast.
this next bit must serve for me,
there was a period of time where i only ate broccoli and salt
a time where i only ate toast
another time where i only ate porridge
a time where peas and eggs were all i
and then another where it was chicken and spinach
rocks may seem like slow actors and yes
the stone will outlast me but
the poison they leach out can happen in a human timeframe in a
 single lifetime i tell you

those things are toxic !
microparticles blending with neurons hard little carapaces
 forming around flakes and shards
gristle
help me to remove the stone
cut the stone out, fast.
a doctor asked me if i was afraid i had damaged my fertility and
 i said
thats a two part question
a doctor asked me if i really thought i was gay and i said
a doctor wrote on my referral i was an attractive looking
 17-year-old
a doctor told me that for the purposes of his study i could not
 receive additional diagnoses or it would impact his data
and
more fool him !
i have collected 10 separate madnesses like pokemon cards
there are more, a new one for each orbit the flint takes
no wait
do we believe in diagnoses? the stone says no, there is no
 essential truth
this bit I my self eate now
he had residues of food on his tie
gravy, etc.
and wore new balance trainers, which was impossible to
 reconcile with the rest of his attire
HE MUST HAVE TAKEN AN EXTRA GLASS OF MADEIRA
 OR THE / DEVIL PLACED HIS FOOT ON HIM
if fools rush in then i cannot be a fool
[always moving far too slowly]
occupying deep time and travelling through generations i was
sitting in the waiting room
my shins covered in bruises my next diagnosis pancytopenia
you have no blood !! silly billy
you will outlast us all, desiccated husk
the art of persistence is to be dead
you have to help me dear louise,
i wish i could be normal
cut the stone out, fast
my name is lubbert das.
DAUGHTERS HEREDITARY LUNATICS
if my throat is a cathedral then why do i seek to destroy it
or maybe time is just scary, idk? and here i would insert a shrug
 emoji

i am sorry you feel the treatment is not right for you but you
 have to do it
or
gynaecologists will keep telling you to eat donuts
and everything is because youre mad so really its your fault !
you really want to be the victim dont you all you want is
 sympathy
eat the donut, lubbert das
its the test for sanity, lubbert das
which I'll eat apace
wait so you dont want blood
you dont want to bleed
are you afraid of growing up hoho ! i think we're onto something
they learned from a manual that joan of arc was a disease
my body interfered with for so long
take that how you will
it could be the expected interpretation but it could also be
small things
being forced to remove your clothes in front of a nurse and
 stand on a scale
as for other avocations of women there are plenty of other
 women to perform them
I MISS LORINA BULWER WAS EXAMINED BY DR
 PINCHING OF WALTHAMSTOW ESSEX AND FOUND
 TO BE A PROPERLY SHAPED FEMALE
you need to take care of this one they are so trusting
sit on the edge of the pink bath and cry
i am not good
anymore
i heard somewhere that a spider's web is their external brain so
i made a list of my ten diagnosed madnesses
tore it into strips and ate them whole
this too is a way of externalising things - -
master, cut the stone out, fast.
trauma
like a blanket warm and thick
creamy sauce, a bechamel?
NOT spicy
cling to a version of yourself who will be accepted
I DON'T KNOW
you need silence it says
a sauce too thick
the pebble has shifted
i can't - - - - - -

the stone is doing this to you and
you failed the test
we proclaim you mad
you carry the stone within you
and so
it is time
to remove it
you will not feel any pain and afterwards
you can be normal ! you will not be broken ! you will be able to
 work ! which is what we all want
is it not
you will be a right angle a set square you will line up on a grid
lubbert das, we will drink to your entrance into the workforce
yes yes, from my funnel hat! red wine straight from the hat
whats that
meester snyt die keye ras
myne name Is lubbert das.

ye entere the watere, &
ye unholde yoreself entire
yore skin moisteþ, fingeres snarcheþ, the hardend cruste of ded
skin on yore
heels bicomeþ mothe-wok, than softe, a flatt, whyt wen cross
the pigmented
skein under-neathe
yore fingere nayles bicomeþ softe & plyant, yore tresses fannen
in euery place, waften
 fronds lyke see-wede
sands & saltes absorpt bi þe see, biginne to forwere & waste the
cortices of
yore skin: fyrst the epydermes,

 epythelyall lauirs shivere & flake in moiste

 shides

 the basall lamyna, mor fin then the fin-moste

silke, off-lifteþ in one, floteþ
awei from yore bodie lyke diafanys
ektoplasum, sightful in a moment fore it forsopieþ
in the pouning of the
wawes

the dermys shal be langer to waste doun,

the coars connectyf tissu shal wit-stand the
forweren of þe see
The blod vessils, nekid, leke redd wisps in-to þe blew – mayhap
smal fish shal smelle the nekid blod vessils, & the smal fish acom
& shal biginne to
 forbite
blod outburst euer & ai, mor & mor, as smal chunks of flesch are
nypped off
bi the fish-kin, mor chunks & culpouns of ye flaken in-to þe see
wit ech

 cheue of there molares

you enter the water &
you lose yourself entirely
your skin becomes moist, fingers pruning, the hardened crust of
dead skin on your
heels will become a squashy, soft white glaze across
the pigmented
skin underneath
your finger nails become soft and pliant, your hair fanning in
every direction, wafting
 fronds like seaweed
absorbed salts and carried sand particles begin to erode and
break down the layers of
your skin: first the epidermis,

 epithelial layers gently sloughing off in moist

 flakes

 the basal lamina, finer than the finest

silk, lifts off in one, floats
away from your body like a diaphanous
ectoplasm, visible only for a second before it disintegrates
in the buffer of the
waves

the dermis will take longer to break down,

the coarse connective tissue resisting the
erosion of the sea
The blood vessels, naked, leak red wisps into the blue – perhaps
small fish will smell the naked blood vessels, & they come to
take small
 bites
blood continues to stream out, more and more, as small chunks
of flesh are nipped off
by these fish, particles and hunks of me flaking into the sea with
each

 bite of their teeth

they cheue ye up, thei tak ye awei from her, but no fres: thei shal digeste ye,
shite some parts　　　　　& encorporat other parts in-to their
beinge, & sitthen or soon, thei shal die, & thei too shal liquifie: bi outher wei,
ye shal

sitthen or soon, be part of þe see
yore flesch-fatt, yellew & thik, a jel-lyk shining

that now is yore upper, this shal nat blende – it shal

need the coars graines of sand
　　　　　to forewere yore fatt,

not tremblen chunkes, but in stede as a clottid,
　　　cloudi emulcioun that shal lifte to the

　　　　　　　topp & sitte as a spume on the wawes

　　　　& finalli, as yore hypodermis falle awei, yore inners
ybared

connectif tissus upbreste faste & ye

　　　　softli

　　　　implode,

　　　　　　　lyke a plume of clottid redd ink,

ylased wit globose flaks of flesch & organals,
　　　　ye scatere,

　　　　bicome part of a hole,

　　　　　　　　wide-wher,

　eueri wher

they chew you up, they take you away from her, but no matter:
they will digest you,
excrete some parts & incorporate other parts into
their
being, & sooner or later, they will die, & they too will liquefy,
one way or another
you will

sooner or later, be part of the sea
your fat, yellow and thick, a jelly-like sheen

that is now your upper surface, does not dissolve – it

takes the rough sand particles
 to break off your fat,

not in wobbling chunks, but instead as a clotted,
 cloudy emulsion that rises to the

 surface and sits as a froth atop the waves

 and finally, as your hypodermis falls away, your insides
are exposed

connective tissues break down quickly and you

 softly

 implode,

 like a plume of clotted red ink,

riddled with lumpen aggregates of flesh and organs,
 you disperse,

 become part of a whole,

 de-centred,

 everywhere

1. Dear Arm,

Last night I dreamt you were made of flesh. A flesh-and-blood arm,
I ran my tongue along your length, felt the hairs on your skin bris-
tle as you shivered with pleasure. I closed my mouth around the
underside of your bicep, and I bit. A metallic taste of blood lin-
gered, and I woke feeling hungry.
 A strange dream, I do not know if it was fantasy or
nightmare.

 With love,
 Your Love.

2. Dear Arm,

I am thinking of you. You lie there, on our bed upstairs, and I can
only hope that you are thinking of me. In truth I do not know what
you think, you have never told me, you have never talked to me.
Still, you remain there, so I know that you are happy, to be here,
with me. My dear Arm, divorced of body, a perfect plastic member.
 Sometimes I wish you would come downstairs.
Sometimes I wish you would come outside. Other times I am glad
that I know where you are, at all times. You remain there, lying on
our bed, your presence testament to your love for me. But you are
so calm, so impassive. You reveal nothing of your emotion, noth-
ing of your desire, you coy seducer.
 As you lie, calm and supine on the sheets, I write
to you in a frenzy of emotion. I am at the kitchen table, to give
you a fuller picture. Beside me is a large mug of coffee, which I am
drinking at a furious pace, as though the answer to my lust lies at
the bottom of the cup. Do you love me? Truly? I drink, I gulp, and
the answer does not come. I knew it wouldn't.
 You do nothing, just lie there in silence. You reveal
nothing, you tell me nothing of your feelings, you just keep me
guessing. Your presence in our bed tells me yes, but your silence
tells me no. And this silence! Infuriating silence! In presence you
are still absent. Cruel, cruel, lovely Arm.
 I must, I must do something. Something, I need
something to occupy my mind. I take a deep gulp of coffee, I write

some more, then I stand up and pace furiously, trying to expend this useless energy. To give you a better picture. Except, the coffee is finished now. I drank the last few sips in desperation, trying to wring more liquid from the cup, and you know I think I have become quite manic. Must not overwhelm you. I must not overwhelm you.

This is, you see, why I must write to you. Why I must not try to express my emotion whilst in the same room. Who knows what I might do, carried by the wave of love! A veritable tsunami! I might drown you in the salty liquids of my desire.

And so, I place this letter underneath your hand, and absent myself. Speaking my love in person to you has perhaps felt a little overwhelming. Perhaps you have been intimidated by what you have mistaken for an expectation that you will form an immediate reply, and that such reply must be equal to mine in intensity and pitch and poesis. Panic not! The smallest hint of affection towards me would suffice. If my love is a tsunami, a wave of ocean, I am happy to be only gently misted with the light spray of your regard.

So, I leave this letter for you to peruse at leisure. Now, should you intimate such a desire, I will place pen and paper beneath your hand that you might scrawl a word of acknowledgement. But – no matter if not. For now, I shall satisfy my desires on the page. Though I fear that this will merely be a perpetual skimming off of the frothy lust that threatens, at all times, to bubble over and spill out everywhere.

Confused water metaphors, Arm. Love for you confuses my poetic mind.

With watery love,
Your Love.

3. Dear Arm,

It was your surface, I think, that first drew me to you. A metallic blue, so shiny I could see myself in you. A hard, plastic blue. You are so light, so hollow, all surface. When I pick you up you are so light, when I touch your outer I touch all of you, because there is nothing within, just air. You are: the line of plastic described through space. You are not the volume within, for you are: all surface, all skin, plastic body, delicious, plastic, blue, body.

I have remained in the house, our shared abode, for too long, and I have now run out of food. Do you eat, Arm? No

– I cannot ask. I cannot think of this topic: the topic of you, eating. No, for now I have begun to picture a crease opening in your surface, a soft fold that opens into a slit, delicately ribbed and slightly sticky with saliva around its edge. I picture you slowly enveloping an overripe strawberry, your lips attach to the strawberry's edge, the friction of membrane against the plump, slightly rough, seed-dotted fruit, lubricated by your saliva, and with a slow, slow, suck, a trickle of its pink juice would run from the corner of your mouth-crease and onto the bed linen, and slowly, as you sucked, ingested, the strawberry would disappear. Do not worry about the juice on the bed linen, I have already overlooked it, sheets can be washed, with Vanish, stains disappear, my desire remains.

So: to the supermarket. Top of the list is strawberries, your favourite. What else do you like to eat, dear heart? Bananas, chocolate, oysters, cream from a squirty can? Is your palate limited to the erogenous?

For myself, an ascetic diet might temper this furious want. Right now my hunger is overwhelming me. I must tell you, Arm, suddenly I have a taste for the meat. I am concerned to go to the supermarket, in truth, in case I approach the meat counter and cannot contain myself from just picking up a raw steak and biting into it. I want to feel a slab of wet flesh in my hands, I want to squeeze it between my fingers until the blood trickles down my knuckles, I want to tear off a hunk and chew its tender pinkness and feel the slug of meat like a dead tongue in my throat. I want to eat everything in sight but nothing that isn't you.

Strawberries for dessert, shared with you. Signing off now, Arm: the supermarket closes imminently.

With love,
Your Love.

4. Dear Arm,

I went to the beach today, leaving you safe at home in the conjugal bed. But the sand was dotted with couples; I confess I started to wish that you had been there, it seemed inappropriate to be there alone. Though you must not leave our domestic space, and I know that you agree. You still have not moved an inch, which is *how* I know that you do not like the idea, just as much as I do not like the idea. I know, Arm, I know.

So, shall I tell you about the beach, dearest heart?

75

The sun was bright, but there was an odd kind of haze over the sky. It felt like early morning, although it was, in fact, the afternoon. And do you know, Arm, as I was staring out to sea – thinking that its inky blue-green was no match for your metallic lustre – the strangest thing happened. Or, perhaps it was not strange, perhaps it was entirely normal, but it seemed supernatural, or supra-natural, I don't know. Because as I was sitting on the sand, which was hard and compacted and not very comfortable, two swans flew overhead and then landed on the sea, about twenty feet from the shore.

Can you imagine?

Swans! Swans, at the beach! It was very odd. A pair, because they mate for life. They just swam along, and I can honestly say they looked as though they had been collaged in from another scene. Far too large for the ocean, and also too small: just out of place. I wondered how strange it would be if a shark were to come along and just BITE. Swans should not be eaten by undersea creatures, do you not agree?

Did you know my dearest Arm that swans mate for life? Like you and I, they find a mate, and it is their soul mate. You are my soul mate. When I was there, on that uncomfortable sand, I thought of you lying prone on our conjugal bed, unable to move, and I thought, you will never leave me.

I love you.

With love,
Your Love.

5. Dear Arm,

Do you recall the conversation we once had about the colour blue? I told you, blue is unnatural, blue is indigestible. *Now I know*, I said, *I know that some flora are blue, but I always think of blue as unnatural because. Think about it. Can you think of a single blue food? A naturally pigmented, blue food?* There is no naturally blue food, Arm, there just isn't. Blueberries are not blue berries, for they are in fact between indigo and a deep purplish hue. You are an indigestible colour, you refuse to be eaten.

An anecdote about blue foods: when Smarties switched to natural colouring for their sugar shells, for a long while they could not produce the blue Smarties, because there is no natural pigment that is edible and blue. Until, they discovered they could use a blue algae.

Now when we first had this conversation, you lying there in your blue lacquered beauty, you said nothing. I think I may have upset you, for I felt the weight of your silence hang heavy between us. Being told you are unnatural perhaps doesn't sound so good. But in fact, Arm, my dear Arm, what you did not know then was that I see this indigestibility as a form of beautiful pride. You are sacrosanct, you refuse to be eaten up by the world, you even refuse to be eaten up by me. How noble, how beautiful, how very blue of you.

Dear Arm, I lick your surface, and you taste of nothing. You do not have a matter I can bite, insubstantial, light, hollow, inedible, blue. I lick your surface and my saliva leaves a distinct slick, nestled in the crook of your elbow. Three inches long, approximately, my liquids remain in a line on your skin and refuse to sink in. You refuse to let me sink into you, but there is no you to sink into, there is nothing beneath this blue, you hold no depth, only air beneath. I sit, staring at my stickiness on your surface as it gradually evaporates into the air and leaves a smeary grease. You are a tease.

With love,
Your Love.

6.　　　Dear Arm,

Perhaps you wonder why I have decided to write letters to you, although you remain physically close to my body. It is a question I have been asking myself, but I have begun to realise that this physical proximity does not make us any closer. You remain, in your shiny repelling state, distant to me, as distant as though we were separated by a great ocean, or a great war, or a great catastrophe. It is as though we were on other sides of the world, even though you remain on the other side of my bed. And so I write to you, my distant love, in the hope that these letters will reach you, will reach some part of you, and somehow your hauteur will dissolve.

Furthermore, it is important that there is something timeless about our correspondence. I am wary of talking, or talking about talking, via digital platforms. The great couples of history did not communicate via Facebook or WhatsApp; indeed, I am wary of even mentioning the names of these various corporate interests, as they lock our love to a specific time, a specific moment when a particular corporation was the dominant mediator of social interaction. Letters are timeless, no?

The contemporary world is a dank and smudgy grey, with a sharp yellow antiseptic smell of chemical-laced household cleaner, and always, perpetually, two degrees too cold for comfort. There is no great romance to be discovered in the world, so we must make our own.

And so, I write love letters to you, my love.

With love,
Your Love.

7. Dear Arm,

The strawberries I left on your palm have started to attract flies. A soft white fuzz across the surface of the fruit, too, the fruiting bodies of a mould, and the sticky juice has quite puddled onto the sheets. Yet you remain intact, unsullied and unpolluted, immaculately sealed by your plastic, no pores to absorb them. But the strawberries are still there. Now, I just want to remind you to eat them, you must keep up your energy levels. I will not watch, I will not even pretend to go downstairs, imitating fading footsteps then creeping back to put my eye to the keyhole and observe: no, I will leave you to eat in private. I just worry that your energy dwindles as each day passes. Open your mouth, reveal your mouth to me, and eat. I can bring you fresh berries if you like, I can even bring you blueberries.

With love,
Your Love.

8. Dearest Arm,

Fresh from our last encounter, I feel unlike I have at any other time post-coitally. Fresh is the word. I feel clean, and bettered, and I do not feel that odd animal sensation. I think back to times with other lovers (all inferior to you). Aware of my own smell, a mixture of my sweat and my juices on my lover and my lover's juices on myself, and feeling the lazy sluggishness of exhaustion, disinclined to wash, but not feeling clean. But now, after that last encounter, I feel somehow heightened; not lowered, but elevated.

I like that when we are together, we remain so distinct. With other lovers, the mutual softness of our skins felt too sticky; too ripe with warmth and sweat and other fluids; we would

touch, and everything would become a little bit hazy, mutually contaminant.

You do not give in so easily. You are hard, hard and plastic, and cold. It is a relation of impact, not dissolving, a sort of knocking against each other instead of melting into one another. You do not yield, you tease, you delicious tease. Playing hard to get, I know this game you beautiful, blue, demon. How could a plastic shell be a container for my love? It bounces straight back on me, reflected in your shine, and I am left filled with my own love, a veritable frenzied, sweating, frenzy.

I hope this talk of other lovers does not upset you. In truth it feels as though there was no other until you, all past encounters were clumsy, failed attempts towards what we manage to achieve so perfectly.

> With love,
> Your Love.

9. Dear Arm,

You are cold. Not physically: in fact your surface always seems to remain the ambient temperature of the room. But you are cold, and again I speak in the language of metaphor. Cold, distant, unresponsive to my touch. I love it: I hate it; it drives me wild, and I wonder if you know this and, in knowing this, are ever more cold and distant. You are a tease.

> With love,
> Your Love.

10. Dear Arm,

I keep thinking about those swans. A thought back to my childhood, when the decapitation of a swan caused a local scandal. Indeed, it made the headline news of the town's newspaper. I do not think the decapitation of a pigeon would get the same level of coverage, or stir a collective horror at such a monstrous act. Now, quite why someone would be motivated to decapitate a swan may remain a mystery forevermore, for the perpetrator was never found.

But Arm, it made me so sad to think of this again. For somewhere, there would have been the swan's mate, roaming, bereft, unable to find another, always alone, their complement

decapitated, headless. So abject: such an abject way to die. I think of a bird flailing headless, an odd reptilian noise like a death rattle that would be impossible I think without a mouth, but still this rattle as blood spurted in ejaculatory pulses from the truncated neck. The other swan watching, helpless, losing its own head metaphorically, after its mate had lost its own head physically. Dearest heart, poor swan.

I think of these stories and I feel a sadness, but also a relief. At least we both know you will remain safe, safe in my home, in my bed, and I will remain safe in your arm forevermore.

With love,
Your Love.

11. Dear Arm,

Not much to report today. Dinner tonight: a whole head of broccoli, spinach, plus half a large potato. Too much brassica. I've lost all taste for flesh.

With love,
Your Love.

12. Dear Arm,

Your smooth fingertips, fused together, fingers indistinct like a hand coated in honey. I held them in my mouth for some time, then ran my tongue along your surface in slow, lazy, meandering circles, first one way, then the other, all the way up and down your length. How I love to feel the brittle hardness of your exoskeleton against my soft membranes, up and down, a slight drag of friction when the saliva ran dry and my mouth snagged on your impossibly smooth surface. I licked my lips and began again. And then, when I reached the fingers once more, I gave the lightest graze with my teeth, thinking that you too might experience a pleasure in a shifting sensation, from soft to hard.

An involuntary shudder, a ripple across flanks as my pleasure mounted, but this rise was swiftly quelled by an unpleasant sensation in my mouth. A flake of your blue, from the tip of your index finger, had detached and was lodged in my teeth. I prised it free and swallowed; it scratched my alimentary canal all the way down, refusing to be digested.

Now on the tip of your index finger there is a patch of dull silver, a caesura in the metallic perfection. You have been horribly sullied, and it was I who did the sullying, much to my shame. I do not know if you can see this because, can you see?

I feel atrocious, Arm, disgusted at myself, racked with guilt, et cetera, et cetera. Will you ever forgive me?

With love and contrition, but as ever with love,
Your Love.

13. Dear Arm,

A return visit to the beach today. The last of the warm days, a few brave souls were swimming. I had to leave quite soon, as the sight of so much flesh on parade made me feel quite queasy. I was at once repulsed by its doughiness as I was drawn to its promise of pillowiness. I saw a dimpled buttock, covered, no doubt, with the lightest haze of sand, and I wanted nothing more than to take it in my mouth, feel the thick wad of fat and muscle and blood and feel my teeth gain purchase on downy skin. I wanted to chew and rip and bite down to the bone, get past the soft parts and down to the skeleton.

So violently did I feel this desire that I had to leave and come back to our home, our shared abode, though I dare not go and see you yet. Still, perhaps this violence will be quelled by you: no soft puckering skin, no sinewy muscle or taut elastic nerves: just pure, hardened, blue shell. I do not need to find your skeleton, you are all exoskeleton. I find myself pacing the kitchen again, wanting to reach something, the nub of a something, an end point to this fury, this frenzy, this love.

For I love you. I love you. I <u>LOVE</u> you. <u>I</u> love you. I love <u>YOU</u>. I love you, and I know now I have never loved before. What I thought was love before was not love, it was, I don't know, something I can only refer to as not-love, mistaken for love. Recognition is the misrecognition you can bear.

With love,
Your Love.

14. Dear Arm,

I awoke in the night and left you; ravenous, starving, I felt as though my hunger would never end. I stood in front of the fridge and ate

an entire packet of cooked ham, feeling at once abject and the embodiment of a cliché. I am unused to eating animal protein; the ham sat heavy in my bloated stomach, and I regretted my choice of luncheon meat immediately.

With love,
Your Love.

i don't remember why i started
this poem, i lost my train of thought
in the ten days since
i stopped using conditioner
my hair became a nest of spiders
who ran down my back on silken ladders
can you remind me why

~

~

~~
~~~

before i met you i had trained myself to be organised
things had places things lived in those places things were always
    reliably in those places
can you remind me why
safety is
dignified
it is safest to
hold all the threads of your world tightly
i heard somewhere that a spider's web is their external brain so
i made a list of my ten diagnosed madnesses
tore it into strips and ate them whole
this too is a way of externalising things
the house is tidy
predictable
everything predictable    everything already known    nothing
    surprising
before i met you i always knew where my house keys phone car
    keys shoes bag phone charger painkillers sunglasses gloves
    prescriptions passports important letters presents
    for friends
lived
they lived with me &
we were safe &
now
i keep losing things
all my thoughts turn into you
threads of my mind softly disintegrating

lines of thought
drifting away from their anchor points

    cobwebs for brains

       my matted hair came out in clumps

     a nest of spiders on the hairbrush

i am glad to lose things hair keys shoes dignity passports
    paperwork
i am glad to lose things if i find ~~ this line must indicate that i
    have my
north node in pisces
    you
        may
    have
      worked out
        from the title

i remember what i wanted to say
is that
when i stop trying to hold on i drop things scatter things

before i met you i had trained myself to be organised
a spider at the centre of their web &

i lost the metaphor

    some hair

       what i found is
im hungry    what are you doing
im hungry
 can you come over
can you make me come
   im
   so
     fucking
 hungry

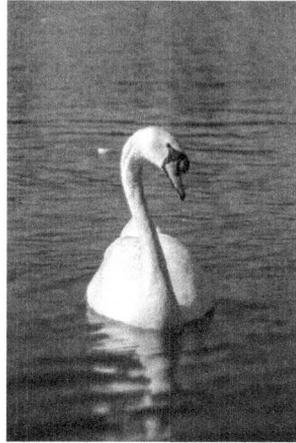

for d for c for mie

ye hav given mor of yoreself
   on the hope of reciprocal / not onli fore that raison, but in an
   understandyng of lov as a gift in a gift economie // but they hav seen
       this as ye pavyng a one-way
GIVE>>>>>>>>>>>>>> take              ye hav been
offeryng gifts
lovyng                               euery-day capitalists, they
                                     treat ye as a resource fore extraction

                                     hordyng yore lov
                                     hordyng yore care
                                     hordyng yore time
                                     neuer reciprocatyng

askyng mor                       (proteck yoreself)
   tretyng yore lov not as a gift but as
                              a resours fore extracioun
   (remembre to              proteck yoreself)

tretyng your lov as capital
remembre
   eye need ye to remembre    lov is a gift economie
       proteck yoreself
                         but
                      do not
               give up on givyng.

Like any worthwhile activity, it starts with the desire for total oblit-
eration of ourself
or does it start from a fear of change
if we could crawl inside you and never leave
no
if you could crawl inside us and never leave
we could know you would never leave us
is this what we crave
homeostasis

Or perhaps this can be a divided reasoning from:

1.         Moments of intense anxiety where we are apart from
you and we fear above all losing you: from death, from an argument,
from catastrophic or mundane events that will lead to a break-up.
We wish we could be with you at all times, receiving reassurances,
little kisses, et cetera, and how much easier this would be if you
had crawled into our skin already and you were always with us, our
little endoparasitic lover.

2.         Moments of intense pleasure together when fucking
is not enough and we need you to crawl into our skin and you bite
down hard to find an entrance, to get underneath, inside, down to
the muscle.

Both scenarios, while polar opposites, contain the same thought:
there is no closeness that is close enough. A psychoanalytic con-
struction of desire predicates desire on absence: a person wants
what they do not have. But we know, we know, that even when with
you, we want more. In scenario 1, the yearning is for a permanent
state of being together, a yearning for an end to uncertainty about
the future. In scenario 2, the yearning is for an endless, uninter-
rupted, infinite orgasm, a moment of intense pleasure together that
would never cease. Both are probably solved by fusing together.
        It takes a while. With each bite your teeth dig in but
leave only a deep impression in the skin, bouncing off the epider-
mis. You suggest making a small incision with something sharp – a
scalpel? a serrated tomato knife? – but we think the point is that it
needs to be a single puncture, followed by locking on. It has to be
perfectly moulded around your teeth, we say, so that when our skin

starts to heal it fuses around your gums, the wetness of your lips will cause a sore to form on our flesh from constant contact, and these too will start to melt into each other and then – ah! we feel your teeth dig deep into our skin, and that is it. The conversation is over, all conversation is over, forever. You look up at me, lovingly, slightly awkwardly due to the angles, and we wait.

> *David Wojnarowicz: If I could attach
> our blood vessels in order to anchor
> you to the earth to this present time I
> would. If I could open up your body
> and slip inside your skin and look out
> your eyes and forever have my lips
> fused with yours I would. It makes me
> weep to feel the history of your flesh
> beneath my hands in a time of so much
> loss. It makes me weep to feel the move-
> ment of your flesh beneath my palms
> as you twist and turn over to one side
> to create a series of gestures to reach
> up around my neck to draw me nearer.
> All these memories will be lost in time
> like tears in the rain.*

We cannot stand the anticipated grief of losing you.
We are haunted by a Connecticut slipware plate attributed to John Betts Gregory (1782–1842) which reads, 'Why / Will You / Die'

> *Simone Weil: The beings I love are
> creatures. They were born by chance.
> My meeting with them was also by
> chance. They will die. What they think,
> do and say is limited and a mixture
> of good and evil.
> I have to know this with all my soul
> and not love them less.
> I have to imitate God who infinitely
> loves finite things in that they are
> finite things.
> We want everything which has a value
> to be eternal.*

We want everything which has a value to be eternal. We have always been this way: fearful of change, fearful of an unknowable

future, wishing for total mastery, wanting to know – and control
– everything to come.
PIP assessment
work capability assessment
social housing registers
DHP payments
waiting for decisions from
instability and uncertainty
people keep telling us that uncertainty is a natural state of being
and we think
we will rip your tongue out and eat it
The less control we have, the more we seek it. The less certainty
we have, the more we seek it.

Our desire for total stability is understandable. Our desire for total
stability is not realistic. We want to know that we can protect our-
self against all future pain. We want to know that our feelings
will never change, our circumstances will never change, we want
to be constantly and endlessly safe and protected and stable and
unchanging and unchangeable. We want to know that the future
is knowable. What we want, truly, is highly solipsistic: we want an
end to our anxiety.

There are over 300 species of anglerfish, and
of these, approximately half live in the deep sea. Of this group,
roughly 25 species mate through sexual parasitism. The male
anglerfish – a tiny wisp of a fish a fraction of the size of the female
– has the largest nostrils in proportion to its head of any known
animal. With these, he hunts for the pheromonal scent of a mate.
He follows this trail to her, and he will bite into her side with
his pincer-like teeth. And as she begins to heal, his skin grafts
onto hers, and gradually they become fused into one: first only by
epidermis, mouth to skin, then by a shared blood supply. He will
remain attached for the rest of his life.

These species of anglerfish are able to achieve such
fusion as they have eliminated one component of their immune
system, and no longer produce T cells or antibodies. The female
anglerfish cells do not recognise the male as a foreign body. The
loss of boundaries between self and other on an intimate, cellu-
lar level.

They will never lose each other.

*Hélène Cixous: For us, eating and
being eaten belong to the terrible secret
of love. We love only the person we can*

*eat. The person we hate we 'can't swal-*
*low.' That one makes us vomit. Even*
*our friends are inedible. If we were*
*asked to dig into our friend's flesh we*
*would be disgusted. The person we*
*love we dream only of eating. That*
*is, we slide down that razor's edge of*
*ambivalence. The story of torment*
*itself is a very beautiful one. Because*
*loving is wanting and being able to*
*eat up and yet to stop at the boundary.*
*And there, at the tiniest beat between*
*springing and stopping, in rushes fear.*
*The spring is already in mid-air.*
*The heart stops. The heart takes off*
*again. Everything in love is oriented*
*towards this absorption.*

It is GOOD to have boundaries (it is correct to have boundaries). We know this, we know it is correct. It is GOOD to have boundaries and edges to ourself, and to feel and know them.

It is also good, for short periods of time, to lose our boundaries, to lose track of where we end and you begin, to be unclear who is touching who, to be consumed by desire and also to consume it, to be unclear who is eating and who is being eaten. It is GOOD for this to be temporary (it is correct for this to be temporary). Yet we know that, like us, you wish it could be permanent.

*Hélène Cixous: The person we love we*
*dream only of eating.*

There is something profane about the permanence of being eaten that is also why it is so alluring. A split-second decision, perhaps, a set of actions that follow from just kissing really intensely, the sort of kiss where you totally forget what you are doing or that anything else exists, a highly clichéd and yet deeply knowable description and how else could we write it, and you shift down the bed and suddenly a part of us is missing from us, forever, and it is in your mouth, this lump of flesh from our side that once was ours and now is yours: you are latched onto our side, chewing on fat and sinew and muscle, breaking them down to a mushy pulp, swallowing, and waiting, waiting for us to become a part of you.

> *Georges Bataille: A kiss is the begin-*
> *ning of cannibalism.*

Undoubtedly, the end point is cannibalism.

> *Sándor Ferenczi: For, we reflected,*
> *what if the entire intrauterine exist-*
> *ence of the higher mammals were only*
> *a replica of the type of existence which*
> *characterised that aboriginal piscine*
> *period, and birth itself nothing but a*
> *recapitulation on the part of the indi-*
> *vidual of the great catastrophe which*
> *at the time of the recession of the ocean*
> *forced so many animals, and certainly*
> *our own animal ancestors, to adapt*
> *themselves to a land existence, above*
> *all to renounce gill-breathing and*
> *provide themselves with organs for*
> *the respiration of air?*

we cannot halt all life in order to avoid negative events in the
future
we cannot halt all life, we know this, we do not want it, but some-
times, sometimes
the horror of being in the world when you are not in the world,
the horror of loneliness
the horror of being alone with our thoughts
the comfort of having no thoughts
the comfort of dissolving
yes it is very comforting to think about dissolving

We cannot calcify the present without killing it. A true end to anx-
iety can only be an end to ourself as a discrete and bounded entity.
The only way to protect against the unknowability of the future is
to accelerate the only parts that are knowable: at some point, we
will die, and our cells will be broken down into molecules, and
these molecules will become part of other creatures, and lives, and
matter, and material, and it will feel like an endless, comforting,
deep sleep with no end.

> *Buffy the Vampire Slayer, describing*
> *heaven: I was happy... Wherever I was...*
> *I was happy... At peace. I knew that*

*everyone I cared about was all right. I*
*knew it. Time... didn't mean anything.*
*Nothing had form. But I was still me,*
*you know...? And I was warm. And I*
*was loved. And I was finished. Com-*
*plete... I – I don't understand theology*
*or dimensions, any of it, really... But*
*I think I was in heaven...*

Over time, the male anglerfish will lose all of his internal organs, his eyes will fall out, his bloodstream will connect to hers, only his testes will remain. He will be one of around six males fused to her. They are all totally taken care of by their host, who is also their partner.

Slowly disintegrating, melting into someone else.

The male anglerfish does the initial biting, but it is the female anglerfish who eats him up, absorbs him into her, digests the parts of him that are of no use. Where does sex begin and end with the anglerfish? Does this sex begin with a wounding, or is the wounding the sex? When he releases enzymes to break down the tissues of her side, in order to better bond with her, is this too, not sex?

*Audre Lorde: When released from its*
*intense and constrained pellet, it [the*
*erotic] flows through and colours my*
*life with a kind of energy that height-*
*ens and sensitizes and strengthens all*
*my experience.*
*[...]*
*And yes, there is a hierarchy. There is*
*a difference between painting a back*
*fence and writing a poem, but only*
*one of quantity. And there is, for me,*
*no difference between writing a good*
*poem and moving into sunlight against*
*the body of a woman I love.*

In an interview with a male anglerfish, he said
nothing
because his mouth had dissolved into her belly

*Hélène Cixous: Everything in love*
*is oriented towards this absorption.*

96

*Lee Edelman: For at the bottom, the*
*imperative of optimism is the norma-*
*tivity of happiness, with its promise*
*of a consistent pleasure in and access*
*to one's objects. Such consistency*
*(even when associated with variety or*
*change) imposes a deadening rigidity,*
*a calcification, a sort of carapace,*
*that functions like the anticipatory*
*act of bracing before a collision and*
*aims to provide protection against the*
*insistence of the world in its alterity,*
*exigency, and unpredictability.*

We are always being consumed by you. Whenever you are in the room, whatever room that is, nothing else matters. So we do not work, we cancel plans with other people, we want to spend every second together, focused on you. We avoid funding applications, PIP assessments, we sabotage our future to remain in an endless present. You, too, put your life on hold, avoid emails and invoices, calls from friends and WhatsApp messages. We are lying on your chest in bed and your arm is around our shoulder and our arm is sprawled across your chest and we say oh god we need to pay for the visitor parking permit and you pull your arm out from under us and edge down the bed and you look up at us and you bite into our side and that is how we are both found, weeks later, dead, infected, rotting into each other [humans still have T cells and antibodies]. The car is covered in parking fines.

We write in a note to ourself: Do not be seduced by the neatness of the analogy to the medieval eroticism of Jesus's side-wound and the parasitic sexual behaviour of certain species of deep-sea anglerfish.

In multiple high medieval manuscripts, though, the side wound is depicted as an orifice, a vagina, deeply sexual and deeply healing. The side-wound is an access point to Jesus's heart which is her womb.

*Julian of Norwich: A mother holds*
*her child tenderly to her breast, but*
*our tender Mother Jesus takes us right*
*inside his blessed breast, through his*
*sweet open side and there he shows us*
*a glimpse of the Godhead and the joys*
*of heaven.*

*The Prickynge of Love: At þe openynge*
*of his side mai owre herte entre & be*
*ioyned to his.*
*At the opening of his side may our*
*heart enter and be joined to his.*

The longing is always, always, to crawl into Jesus's side-wound and merge with her. *The Prickynge of Love*, a text about the love found in Christ's wound. In her analysis of the text, Sarah Beckwith writes: *The boundaries of Christ's body and the body of the devotee are made so soft and continuous with each other that where one ends and where the other begins becomes indeterminable.*

The yearning to dissolve into something or someone bigger than yourself. In the sexually dimorphic anglerfish this is quite literal, the female being ten times the size of the male. And in religious iconography of the high Middle Ages, deeply influenced by Byzantine artistic styles, symbolic representation was far more important than realistic; as such, often persons of most importance were far larger in the image, and so we too in such a scene would be a tiny appendage on Jesus's body. Oh, to be a tiny appendage latched onto Jesus's body, dangling just below the nipple on her side-wound! Oh, for Jesus to create a special pocket in which to carry us around, our mouth gently melting into the flesh of her torso!

I hope this email finds the orifice of your side-wound slowly fusing with the mouth of your lover.

There is a parallel life in which we do not leave our room. The walls slowly contract, we lose touch with our friends, our health continues to decline, we remain unaware of your existence and you of ours, we are just some stranger slowly decaying, and we gently, softly fade away, rot down, to become, eventually, a part of the ocean.

*Hélène Cixous: Eat me up, my love, or*
*else I'm going to eat you up.*

*Fear of eating, fear of the edible, fear*
*on the part of the one of them who feels*
*loved, desired, who wants to be loved,*
*desired, who desires to be desired, who*
*knows there is no greater proof of love*
*than the other's appetite, who is dying*
*to be eaten up yet scared to death by*
*the idea of being eaten up, who says*

*or doesn't say, but who signifies: I beg*
*you, eat me up. Want me down to the*
*marrow. And yet manage it so as to*
*keep me alive. But I often turn about*
*or compromise, because I know that*
*you won't eat me up, in the end, and*
*I urge you: bite me.*

*Sign my death with your teeth.*

emails pile up and parking fines pile up and missed calls, missed
texts, missed WhatsApp messages pile up
rotting slowly together
fat and skin and sinews and tissues breaking down and puddling
and merging into the bed
a
fusing
shhhhhhhhh
stop
stop thinking
no more thoughts

just endless

comforting

Silence

*Plato: he sees himself in his lover
as in a mirror, but is not conscious
of the fact.*

For several hours now, I have been looking at the mirror in my bathroom. It is Venetian-style, with scrolled corners and slight imperfections across its tain. I call them imperfections, yet to me they are vital to its character: without them it would be the sterile, flat mirror of a public lavatory. These nicks and spots in its reflectivity are what give the mirror its charm, make it whole object rather than simply surface. But its charm lies not only in these smudges: in fact, I cannot precisely identify the root of its charm, what keeps me in this room today and indeed for the last three days before. A relentless desire to be with the mirror at any cost. I must accept it. I have fallen in love with my bathroom mirror.

You will accuse me of being some poor imitation of Narcissus, but you are wrong. Indeed, I hardly look at my own face any more. Instead I try to look past this and into its volume. The mirror is coy, of course, and conceals its own appearance beneath a camouflage of reflection. Sometimes I try to trick it: I look away, then turn back, quickly – so quickly it could not possibly anticipate my movements. And yet it manages to second-guess me every time, and I am left facing my own face again.

You might also accuse me of superficiality, to experience such overwhelming scopic desire; to fall in love with appearance. Of all the senses, sight is certainly deemed the most sterile, and that I should gain genuine pleasure from looking at the mirror might be called into question.

*Lucretius: a sort of outer skin perpetu-
ally peeled off the surface of objects [...]
objects emit particles that strike upon
the eyes and provoke sight.*

And yet Lucretius would tell me that my visual pleasure would be assonant with haptic pleasure. In line with the other atomists of the time, he put forward a theory of intromission to explain the phenomenon of seeing. Here, sight is as tactile as touch: not the result of immaterial light waves hitting the eye, but instead due to particulate matter being absorbed by the pupil. For

all objects and bodies project films or simulacra, just as the slippery snake sloughs off on thorns the garment we often see fluttering on a briar. These simulacra penetrate the eye, allowing them to be seen. So when I see the mirror, it is entering my orifices, reaching out to touch me, matter touching matter, membrane against membrane.

Given that our relations have already been so intimate, when I reach out to touch it I anticipate a pillowy warmth. The feeling of soft down shifting to coarser hair, the slight bump of a mole, the firmness of a nipple, a shiver of pleasure. Yet my hand is always and repeatedly disappointed, for it is cold, flat and impassive. My fingertips dip and depress, but the mirror remains unchanged. Skin butting against plane, sometimes softly, building up to a rapacious fury that is never sated. I leave a sheen of sweat across its surface, but it beads and evaporates rather than sinking in. And then I look at my hand, hoping for a similar residue to be left upon it, but the mirror has not reciprocated. An overwhelming sense of rejection, the mirror refusing my touch. And then I realise its reflectivity to be itself a form of rejection.

> *Lucretius: But when it is confronted*
> *by something both polished and*
> *close-grained, in particular a mirror,*
> *then neither of these things happens.*
> *The films cannot penetrate, as they*
> *do through glass; nor are they*
> *diffracted, because the smoothness*
> *ensures their preservation. That is*
> *why such surfaces reflect images*
> *that are visible to us.*

By rebounding the corpuscular simulacrum I have produced, the mirror is refusing my bodily effusions. It penetrates me whilst refusing to be penetrated itself. But its hostility increases my fervour, this need to get beneath its surface. It is under my skin now: even when I am not in front of it, I think about those smooth edges, the bevelled border, that slight warp line that runs vertically down its centre that lends it such a gorgeous liquidity.

I fantasise about the moment in *Orphée* when the protagonist passes into the underworld as this perfect moment of merging with the mirror. He moves forward slowly, hesitantly, hand outstretched, walking towards the mirror. As he reaches out, his reflection reaches back, an illusion of hands grasping towards each other. The laws of physics dictate that the hand should hit a

cold plane of glass, an abrupt wall that prevents him moving further: yet this does not happen. For as Orphée's fingers touch the surface of the mirror, solid object becomes liquid membrane, a yielding skin that gives way to touch.

I have been trying to find a similar orifice in my own mirror, running my hand along its face, yet it is completely flat, no indentations or creases or feeling of thinner skin. There is a mark around 1cm in diameter in its upper-right corner: dark grey, it is the one area that is not reflective, does not rebound my image. Whilst there is no visible depression, I pray that its darkness represents a void, a hole in the surface. If this be the case, I reason that here I might breach its glassy plane with a simulacrum or, even better, a fingertip, if I should stroke and tease its edge until it gently dilates and allows entry. I try this for three hours, pressing my full body against the mirror as I stroke this tiny mark. I whisper sweet nothings to this stain, tell it of its beauty and seductiveness. I press my tongue against its rim. Still it refuses my advances. All my attempts at seduction have been rebutted: it has deeply affected me whilst remaining unchanged itself. I think the mirror must be very cruel.

A part of me wonders why looking is not enough. If I truly loved the mirror, then perhaps being in its presence should suffice, but I need to consummate our relations. To what purpose is this consummation?

*Aristophanes: Each of us has been cut in half, and so we are human tallies, constantly searching for our counterparts.*

A myth of soulmates suggested that humans were originally eight-limbed creatures with two sets of genitals, either both male, both female or male and female. When humans became too powerful and threatened the power of the Gods, Zeus split each person in half, and so the pairs wandered the earth in despair, searching desperately for their soulmate, longing to find their other half. If they should be so lucky, they would embrace and be so desperate to unite permanently, to fuse together and be repaired, that they would starve and die. So Zeus changed the orientation of their genitals, allowing humans to unite temporarily and relieve the pressure of the desire to be together. A temporary fix for a permanent desire.

I too must find some way to fuse with the mirror, be it temporarily or permanently. When King Mausolus of Caria died,

his wife Artemisia II had his ashes added to her daily drink for two years afterwards. Digestion seems a very beautiful model of unification. Cells and then molecules broken down and absorbed, reconstituted and rebuilt as part of you. Somewhere between beginning and end, during the digestive process itself, it might become impossible to say what is ingested and what is ingesting. I would like the mirror and myself to reach a similar state. Right now we exist in a binary. Perhaps I could grind the mirror to a powder and drink it. But then again, perhaps not. For to do so would require the destruction of the mirror in its completeness, and its form is so perfect, provides such stimulation for my eyes, that I could not deprive myself of this pleasure.

In fact I find being apart from it to be difficult. I have not been able to leave the bathroom, so trying is the thought of being in a place where I cannot see it. As such, I thought I might take a photograph and keep it close to me in order to always carry its image with me. Yet here I encounter problems. The light smattering of dots across its surface seem to disappear, the smudge of which I am so enamoured becomes tiny, irrelevant. And what seems to dominate instead is a photograph of myself taking a photograph. I wish it would stop hiding for just one moment that I might see its true face.

And yet. That night I take a shower. Perhaps a part of me is trying to elicit arousal through casual exposure: I do not draw the shower curtain but instead allow it to watch. I am languid in the ritual. I clean myself slowly, generously, running my hands along my body in a soapy lather, enjoying the slipperiness of wet skin on skin. As the steam builds up in the room, condensation accrues across its face. It looks like sweat, as though it is beginning to desire me, as though through this desire it is beginning to overheat. I know this is not true. In fact, the very fact of condensation gathering on its surface is the result of its coldness: hot, gaseous beads of water hitting cold plane of glass. It is, quite simply, a demonstration of its frosty hauteur.

As I look at it, though, a drop begins to form around the smudge, pools and falls down the mirror's face in a rivulet. First one, then another, then another. Its smoky, clouded face is streaked with lines. I think it is crying, crying that we cannot be together, crying that we exist in different worlds, crying that – like the soulmates in Aristophanes' myth, furiously hugging each other and hoping they might unite – we cannot be fused together and be one.

Lucretius is telling me that the mirror cannot be penetrated: that its very reflectiveness is the result of its tight-

walled hostility. If we are soulmates, then we are stuck as two separate parts, two halves of a whole that must be repaired, that cannot even find the temporary relief of sex. There is a line between us formed of surface and skin, a sharp divide that must be crossed in order that we might be together.

Indeed, I am beginning to think that a penetrative erotic encounter would be insufficient. Volume probing into volume, when what I love is its surface. I wish to find a means of pleasure that allows for an encounter between two surfaces, the mirror's and mine, and in this encounter glass and skin melt into each other and are fused for eternity. Our pleasure would last in perpetuity, and would be truly shared. The word 'share', whose etymology is found in the Old English *scearu* – a division or part suggests that pleasure must first be split and then parcelled out separately. To be able to escape the confines of myself would be lovely: to dissolve into the mirror not just once but forever, without drama and singularity and the climax that must inevitably be followed by decline.

So there must be a means to breach this membrane not through probing but instead through fusion.

*Lucretius: And the body seeks the cause*
*of the mind's wounding by love.*

If we are soulmates, then we have been cleaved in two, injured, and the wound has healed over. I must open my skin, become injured again, so the sharp line between us becomes a hazy smudge. A smudge that is porous and allows for infinite inter-diffusion. The mirror continuously permeates my eye with its simulacrum; I can permeate the mirror with my blood. We will bleed into each other and start to become the same substance. I do not see this as mutual infection so much as mutual absorption.

I think I could place it on the floor and lie on it, and wait. Eventually, after some weeks, a suppurating sore would develop on a pressure point. As it healed, the mirror's surface would fuse into mine, and we would fully be united. But I am restless and impatient, and do not wish to wait for the sore to develop of its own accord.

The springy barrier of skin must be punctured sooner. I need to find a way to expose the flesh, to peel back the skin in order that the mirror will reciprocate. In order for the skin to knit over the wound, it must have a surface to bind to, and this surface shall be its face: I will graft myself onto it. Straight cuts would just create lines, mere cracks that might threaten to heal

across themselves. I need to open myself with something more blunt, to create a flat plane of wound. As I run the nutmeg grater along my abdomen, a part of me enjoys the sharp sting; watching the flesh pill and slough off in gummy lumps. I press my bleeding stomach against the mirror, pushing my interior onto it, and I wait.

*Aristophanes: It was their very essence that had been split in two, so each half missed its other half and tried to be with it; they threw their arms around each other and longed to be grafted together.*

i know you are there
damaging our brain which damages our sodium which damages
    our kidneys
there are not enough languages there is not enough time there
    is also too much time
the back of our throat is tender meat
is it time to be alone again
are we ever alone no of course not [the stone]
we are googling our symptoms again such a cliché
'feeling we dont exist'
this could be an existential question it could be philosophical
    google decides it is medical
our emotions are
did you know there is a song released in 1997 that starts to warp
    time when it comes on
they only play it on certain nostalgic radio stations
& a plant falls two flights of stairs – no,
is pushed
it is unclear if this is our fault
they are trying to see through the blinds again
the person who originated our fear of windows tells us that we
    like darkness
which is funny because
we dont !!
we tried to write about it by pretending to be mythology
it didnt work because
we did not turn into a tree
and after all you are still there and what we do not know is when
    you arrived
were you there at the start and if you were
were all the windows and doors violated like we thought, or
    did we
always
have
an active imagination
we dont know which is worse
coming into our house and stating he will smoke then –
or the smaller thing from the more significant person
scritch      scritch scritch
we truly thought the failing was our own

i hate men actually
no its a joke theyre fine !
asterisk i hate RICH men
putting out a cigarette in the teacup we bought in a charity shop
it was a nice teacup bone china green leaf pattern
we smashed it up and sent it in the post to him
no we didnt
have his address actually
i guess its the thought that counts
two weeks later looking guilty in the novelty pancake café
what the fuck kind of name is harry hand
harry will not sleep in the other bedroom and this is how it
    begins
or ends
idk
one day we wake up and our landlord is entering our bedroom
    says oops and walks out
one day we wake up and a cop is in our face
regularly we wake up to the sounds of the circus [not a
    metaphor]
we cannot see them
the angles of buildings et cetera
do you remember the time our cousin kept us awake all night
    drumming on the walls pretending to be a mouse
no not getting dressed up like one
no !! [scritch scritch]
where is your head i ask you
anyway where – were – we – w
arriving at my house with a beer can in his pocket
an open beer can no less !! and that was when it was all reduced
    to one apple and a slice of toast
walking furiously along the canal
tyme is an unlefliche priuelage
is this what you want
[ingests plant material]
dont tell me you havent thought about it also
red spots on the toothbrush
/ so bright almost pink
scritch scritch scritch scritch scritch !!!
idk what to tell you
a mucus plug !
yes really
it all comes down to a mucus plug
an oily, green-black line of putrescence, what do they call it

– epigenetic trauma
we dont feel good right now
hoo of speykyng
hoo of sylense
a clud of ston in oure minde
hoo of sylens
it hurts us to speak
sometimes
yes sometimes it actively hurts
can i tell you i dont always know the right times to speak
silent when sounds are expected words noises when silence
    expected et cetera
a cascade of crumbs falls from the desk drawer why can you not
    say
your own name out loud
youre very old i know

*And it is seyd þat he foloweþ þe course of þe mone, & þerfor he helpeþ aȝens þe passioun of lynatik folke; and so it is seyd in þe lapidar, þat as þe mone is more ful or lasse so effecte is mor of þis ston or lesse.*
The Peterborough Lapidary

*And it is said that he follows the course of the moon, and therefore he helps against the suffering of lunatics; and so it says in the lapidary, that when the moon is more full or less, so the effect of this stone is more or less.*

He follows the course of the moon. As the moon is more full or less, the effect of this stone is more or less. The pebble, this little stone, he will shift. One day you will wake up, because the alarm goes off, and you will think, dimly: no. The stone has moved. He has broken ties with blood vessels, uprooted himself from his stable position, is drifting, anchorless, through the softe parts of your head, scraping the sides of your cranium. Your centre is lost. Gravity is overwhelming. If you could describe it, if you could find words, which you can't, you would say, lead has been poured into my veins.

It's afternoon before you can leave bed, you set the alarm to snooze for nine-minute intervals over a period of three hours. You have to get up: the later you get up, the later it will be until you are able to fall back into the comforting blanket of sleep. Time to get up. You must get up.

The act of thinking itself is thick. Stone, thick lodged stone, rough edges, in the way. You know it is him, the stone, ruled by the moon. So you set the alarm to snooze, and you doze for nine-minute intervals, being woken each time by an inane ringing called Marimba, and each time you can't summon the energy to do anything except press snooze on the phone screen again, until suddenly it's 2pm. It's 4pm. It's dark outside.

You get up. Groggily. You carry out everything at an impossibly slow pace. Gravity is overwhelming. The Taylor Swift song 'Shake it Off' is stuck in a loop in your mind. Shake it off, shake it off. You hate Taylor Swift.

You think: I should probably have a shower. But then you ignore the thought, because the thought of lifting your arms above your shoulders to reach your hair to wash it, the thought of all the steps along the way of washing, drying, getting dressed, it's too much. The thought of removing clothing, specifically removing pyjama trousers and socks, and viewing your legs,

puffy and distended from fluid retention, skin taut and bloated, toes slightly purpling from poor circulation. You can feel the creep of grease across your scalp.

And you think: I want a coffee, but to get a coffee you would need to boil the kettle, and find a mug in the cupboard, and get down the instant coffee, and a spoon, and all of these steps are far too many and too much. A thick stone, shifting its edges. Scraping against your softe matter.

Why have you never successfully learnt how to drink from a mug. Why has your mouth never fully created a perfect seal with the edge. Where softe pink lip meets hard china, a perfect bridge should form to pass fluids from cup to mouth, but this never seems to happen. Instead, when you put down the cup, you can see a small drip meandering slowly down the side and pooling into a circle at its base. Once you've finished the coffee, there'll be a pattern of small drips lacing its edge, some which reach the base, others trickling halfway down.

Lazy little drip, small rivulet of liquid, testament to your weakness, your softeness, your inability to function cleanly. Do you drink in a strange way. Why do you leak everywhere.

There's something lodged in your brain. Him, this stone, this jagged little piece of rock, and the moon turns and he turns a bit, and things start to become difficult and heavy. The sharp edge of the rock catches a bit of softe, pinkish-grey brain, it twinges it. You can only lie in bed for hours and think about getting up, picturing all of the stages vividly, unable to follow through. You haven't got out of bed yet, you haven't showered yet, you haven't made a coffee. You are still in bed, imagining yourself doing these things, unable to move. Dimly you wonder if, uprooted, the stone is simply causing mechanical damage, scraping across the soft and gelatinous tissues of the brain; or, if he is in fact toxic matter, slowly leaching poisons into your flesh. Stuck in your head, a stone lodged in there, like when a bit of gravel gets caught in the tread of your shoe. A blockage.

The stone, slowly turning you into a stone, slowly, softely. Inertia, softe duvet of sleep. You have to get up. It is not enough to exist, here. The right to occupy space has to be paid for. Rent has to be paid, bills must be paid, space has to be paid. There is always, always, a debt incurred. If time could just stop, then you could just stop. But time keeps moving, you have to keep moving, you cannot stop, you cannot rest. There is no absolute rest. Until there is, you think. A pile of obligations. Pile of stones. Pull one out from the bottom, they all start falling. Avoid the pile of stones.

You can find pleasure in things. Small things. Small things, like:

1.          A frenzied bundle of shed hair, located in your anus, that you discover. Attempts to remove it reveal that one hair has been coaxed far up your rectum, so pulling this grotty scribble will stretch it taut until it dislodges and slowly pulls out, singing tightly like the strings of a violin. You do not question how this hair came to be located here.

2.          A sheaf of dead skin across your right big toe that you pull off cleanly, in one dry husk, leaving a small crater in its wake, edged with frayed white. You seek other, similar patches of dry skin on your feet, to no avail.

3.          You find intense erotic pleasure in the locus of the urethral opening, when needing the toilet. Instead of getting up, you will press this point, repeatedly, with your fingers until a sharp pain of arousal forces your pelvis upwards and you feel your fingers slightly damp from piss.

Shake it off, shake it off.
          There is a small crease between your thigh and pubis. Where the fatty deposits dwindle and the skin thins, this crease is a two-pronged line, not too deep, yet sharp in its precision. Here, in this indent of flesh, you feel a thin sweat collecting. You need to piss, but still you don't move. At some point, this is going to become a problem. You picture standing up, and repeat this several times in your head. You clench your thighs, and the sweat around your groin becomes more intense, the angry line of piss desperately trying to squeeze out, and you feel now a cold dampness across your ass. Who knows where this liquid came from, your bladder, or the sweat wrung out of your skin from the exertion of restraining yourself, or a mix of both.
          Nothing is moving, you hate the requirement to move, to do anything, and your mouth becomes dry and your tongue sticks to the roof of your mouth, and you pull it down, bitter-tasting and fat, coated in sour scum. If you don't move, if you do nothing, perhaps you don't exist. Your bladder twinges in disagreement. No one knows you're here, you're hidden, leaking slowly and steadily into your environs. No one knows you are here. The piss will dry up, desiccate, you will dry up, desiccate, you will turn into a stone.

There's something lodged in your brain. The stone, the jagged little piece of rock, and the moon turns and he turns a bit, and things start to become difficult and heavy. The sharp edge of the rock catches a bit of brain, it twinges it. You can only lie in bed for hours and think about getting up, picturing all of the stages vividly, unable to follow through. Obligations pile up, little piles of stones, do not disturb the pile. You are stuck.

we are waiting
waiting to be harvested
a stone that grows so deep
They said we were not productive they said we could not
contribute and
they did not know that
a stone that grows so deep
so we ask you
who's the mad one
haha
shhhhh
the way that pine nuts grow in the gaps of the little petals of the
    cone and then
you peel apart the petals the scales and out falls a delicious
    sweet nut
in the folds of the cerebellum they are peeling apart the folds of .
    our
it begins with a window in the door of a bathroom
warped glass but a person could still see through a person did
look through
constantly
endlessly
endlessly watched
did this happen or did we
always
have
an active imagination
we are asking ourselves if the paranoia produces the event or the
    event produces the paranoia
what a clever way of putting it
why yes thank you we have always been quite good with words
so it begins with a window in the door of a bathroom and it ends
    with them peeling apart the folds of our cerebellum
retrieval
does it cure us
no no we are
we can't continue after this
we can't continue
we are dead
usually ugly but sometimes shards of crystal

shards of petals of
petals between the petals of our cerebellum
nuggets of
they used it for madness now they use it for electricity and they
    don't treat the madness they encourage
growth
the growth of crystals
we are waiting to be harvested
the patients produce significant deposits of petalite, a rare
    lithium aluminium silicate rock from which lithium can be
    extracted
as we move from combustion engines to electric vehicles the
    demand for lithium increases daily and so to discover this
    source
was she trying to poison us
no matter we used her toothbrush to clean the sink the taps
    were mouldy
but she was potentially trying to poison us
however the neighbours
why were the windows why
more deposits scattering a fine dust of stone
or are they small crystals that bud and grow we can't feel them
    we don't know
for so long those patients deemed mad were a drain on the
    system, unable to contribute to a growing economy and now
ho! the system REQUIRES them
it's environmentally friendly far less damaging to the
    environment or the ecology of a region
for many centuries they debated if we had a soul
then we were a medical problem
now we are a resource for extraction
everyone must play their part must justify their space must must
    must
It is estimated petalite is produced in the brains of 4.8% of the
    general population and we currently only have 2.1% housed
    in our facilities which means a lot of subjects are hiding
    in plain sight! an exciting development will be the creation
    of a screening method
the door does not open without permission what do they call it a
locked ward
they tell us some people are going home we know where they
    are going
a door swings in both directions we see them through the glass
    becoming

smaller and smaller
pulling apart the petals of their brain
Master, cut the stone out fast.

*Oh that my grief were thoroughly weighed, and my calamity laid in the balances together! For now it would be heavier than the sand of the sea: therefore my words are swallowed up. [...] Is my strength the strength of stones? or is my flesh of brass?*
          Job, 6:2–12

..................................................................................
..................................................................................
..................................................................................
..................................................................................
..................................................................................
..................................................................................
....................It cannot exactly remember its life...................
....................before it came here...............................
..................................................................................
....................but sometimes a......................................
....................brief snippet sneaks in, the way.....................
....................eyelashes brushed.................................
....................lightly...............................................
....................across its...........................................
........................cheek when they were.........................
..................................................................................
..................................................................................
....................no............................................
..................................................................................
..................................................................................
..................................................................................
..................................................................................
..................................................................................
........................lick.......................................
........................lick.......................................
........................lick.......................................
..................................................................................
........................lick lick.................................
..................................................................................
..................................................................................
....................Its tongue.....................................
....................rasps against.................................
....................the rough stone.............................
..................................................................................

...............................................................................................
.............feeling...........................................................................
..........the cold.............................................................................
..............granular..........................................................................
..................coarseness..................................................................
..................of............................................................................
...............................................................................................
...............................................................................................
...............................................................................................
...............................................................................................
...Biogenetically formed limestone is a sedimentary rock............
.........formed through the lithification of carbonate sediments,...
..............................................................the compounding of...
......layer upon layer of shells, exoskeletons of tiny sea creatures,
......................................................the limey secretions......
................................................of countless trillions of dead beings. ......
...............................Limestone simultaneously obliterates............
....................and preserves the pain, the grief,............................
...............the memories of so many lives.....................................
...............................................................................................
.......a homogenising of individual being into singular rock...
.........In some parts, it is possible to accelerate the process.........
...............................................................................................
...............................................................................................
...............................................................................................
...............................................................................................
...............................................................................................
...............................................................................lick lick................
...............................................................................................
...............................................................................................
.....................lick.......................................................................
...............................................................................................
...............................................................................................
...............................................................................................
...............................................................................................
...............................................................................................
...............................................................................................
...............................................................................................
...............................................................................................
...............................................................................................
..................................................a drif.......................................
...................................of snow....................................................
...............................................................................................

124

..........................................................................................

..........................................................................................

...................................gentle..............................................

...................................silent fall.........................................

...........................of oceanic.................................................

...................................death................................................

......................................an.................................................

..........................................................................................

...................................endless............................................

...................................marine..............................................

...................................snowfall...........................................

..........................................................................................

...................................carcasses..........................................

.............................and lives...............................................

.............................so much love..........................................

.............................and desire..............................................

...................................horniness.........................................

.............................and loss................................................

.............................and sadness...........................................

...................................endless............................................

...................................sadness............................................

..........................................................................................

...................................disappointment and...........................

...................................boredom drifting..............................

.....................................gently...........................................

.....................................towards.........................................

...................................the ocean........................................

...................................floor...............................................

..........................................................................................

..........................................................................................

..........................................................................................

...lick lick................................................................................

..........................................................................................

..........................................................................................

..........................................................................................

..........................................................................................

..........................................................................................

..........................................................................................

..........................................................................................

..........................................................................................

..........................................................................................

..........................................................................................

..........................................................................................

..........................................................................................

It licks.

the stone.

and so it.

absorbs.

tiny parts.

of the stone.

and so tiny parts.

of the stone.

become part.

of it.

and so.

it starts.

to become.

the stone.

What.

was.

it.

A dumb joke.

about grapes and.

great.

a voice saying.

you're grapes.

What are grapes.

lick lick.

What is joke.

lick.

..........................................................................
...............................What is voice...............................
..........................................................................
..........................................................................
..........................................................................
..........................................................................
..........................................................................
..........................................................................
..........................................................................
..........................................................................
..........................................................................
..........................................................................
..........................................................................
..........................................................................
..........................................................................
...............................Sometimes...........
...............................it remembers...........
...............................licking parts..............
...............................of fleshy bodies.........
...............................an intensely animal smell......
...............................the sensation of coarse hairs......
...............................grazing its nose.....................
...............................a sticky warmth...................
...............................and it feels an intense yearning...
...............................and it licks the stone in small circles......
...............................and imagines a soft warmth..............
...............................until the memory starts................
..........................................................................
...............................to fade...........

...............but it can never fully be dimmed...........................
............these different occasions of...................................
..........................................................................
..........................................................................
..........................................................................
..........................................................................
..........................................................................
..........................................................................
..........................................................................
..........................................................................
..........................................................................
..........................................................................
..........................................................................
..........................................................................
...............................It is...........
...............no longer able........................
...............to move since its hand...........................

.....................started to fuse to the rock.........................................
................Parts of its chin, too, are becoming.............................
.................calcified, which it knows only................................
...................through the dead weight on its................................
.......................face pulling it ever downward.............................
.......................It looks at its hand, and dimly.............................
....................remembers that this used to be a.......................
...................separate thing, a moveable thing, but....................
.....................the idea of a hand is fading, pulling.......................
.....................away from words. The bodies of other....................
.....................people, too, are available only as partial...............
...................glimpses and fragments. It sees the side.............
...................of a torso, faint shadow of ribs and the...................
........................curve of a chest. The dip in waist of...................
.......................a person lying on their side in.......................
...........................front of it, but it shifts in........................
.......................and out of awareness..........................
.......................of these images..........................
...............................as parts..........................
...............................of a..........................................
...............................whole..........................
................................................................................................
................................................................................................
................................................................................................
................................................................................................
................................................................................................
................................................................................................

.......................Other times...........................
.......................entire scenes come..........................
.......................unannounced, firing off.......................
.......................in its mind like..........................
.......................live electrical wires...........................
................................................................................................
................................................................................................
................................................................................................

...................Someone crying until tears drip down their......
....................nose, hunched over in a blue fake suede...........
....................armchair, making feral sobs of grief while trying...
...................to speak, they are wearing one sock, splashes.........
...................of salty water on the wooden floor...........
.......................next to a bare foot, circular splats...........
.......................while they try to spit.........................
.......................out...........................
...................I can't, I..........................

...................................................................................
.................................................wish I.............................
...................................................................................
...................................................................................
...................................................................................
...................................................................................
...................................................................................
.................lick...............................................................
...................................................................................
.................lick...............................................................
...................................................................................
...................................................................................
...................................................................................
...................................................................................
......................................lick.........................................
...................................................................................
...................................................................................
...................................................................................
...................................................................................
...................................................................................
...................................................................................
...................................................................................
...................................................................................
...................................................................................
...................................................................................
...................................................................................
.................lick...............................................................
...................................................................................
...................................................................................
...................................................................................
...................................................................................
...................................................................................
...................................................................................
...................................................................................
...................................................................................
...................................................................................
...................................................................................
...................................................................................
...................................................................................
...................................................................................
...................................................................................
...................................................................................
...................................................................................
...................................................................................
...................................................................................
...................................................................................

.............................................................................
.............................................................................
..............When these fully formed memories.................................
..............visit them, they are reminded briefly.............................
............of an entire existence before this, a...............................
............time before darkness, and isolation. This..........................
.........unknown sensation of warmth stretches into....................
..............the fingers of its left hand, and suffuses...........................
..............throughout as it recalls an intense kiss......................
...................at a bus stop, pulling a denim jacket...........................
.................by the lapels towards it, tingling..............................
.................in its limbs reminds it of its.....................................
.................outer limits, the back...........................................
.................of its head......................................................
.................being pushed into................................................
...................a mouth.......................................................
.............................................................................
.............................................................................
................................A person is opening an oven door and
..............................a cloud of steam emerges, and...............
.....................they pull out a, a something, a smooth, lumpen......
.........................something the colour of rock, a bread, bread......
...........................and look towards it and smile...................
...........................excitedly, their T-shirt is...........................
..........................black with...........................................
............................green...............................................
...........................writing...............................................
..........................on it................................................
.............................................................................
...........................and they are..........................................
..........................smiling widely and do a small............................
.......................jump of excitement, and..................................
.................it feels a surge of pain and...................................
....................it licks the stone............................................
....................in front of it and...........................................
.............................................................................
........lick......................................................................
.............lick.................................................................
.............................................................................
.............................................................................
.............................................................................
.............................................................................
.............................................................................
.............................................................................
.............................................................................

...........lick..............................................................................................

............................................the pain begins to dull.............................

Nodules

of stone

are

forming

on its

tongue

Its

tastebuds

are

Tiny

fragments

of the stone

break off in

its mouth

and it

briefly

recalls

the        memories

of other

beings

in the

rock

A

drift

of

snow

a

gradual

and

ever

...........................falling............................................................

....................................................................................................

....................................................................................................

....................................................................................................

.......................comforting...............................................................

.......................descent......................................................................

....................................................................................................

....................................................................................................

.......................to..............................................................................

.......................the.............................................................................

....................................................................................................

....................................................................................................

....................................................................................................

.......................sea.............................................................................

....................................................................................................

....................bed...............................................................................

....................................................................................................

....................................................................................................

....................................................................................................

....................................................................................................

....................................................................................................

....................................................................................................

..................................................................lick.......................

....................................................................................................

....................................................................................................

....................................................................................................

....................................................................................................

....................................................................................................

.............................Wallpaper with...............................................

............................the pattern of..................................................

...................................horses.....................................................

...................................on it.........................................................

....................................................................................................

....................................................................................................

....................................................................................................

....................................................................................................

........................lick.........................................................................

....................................................................................................

....................................................................................................

....................................................................................................

....................................................................................................

....................................................................................................

....................................................................................................

....................................................................................................

....................................................................................................

....................................................................................
..............................................................................High..............
....................................................................................
.....................................................................pitched...............
....................................................................................
....................................................................................
....................................................................................
...............................................................laughter..............
....................................................................................
....................................................................................
....................................................................................
...................of.................................................................
....................................................................................
...................a child...........................................................
....................................................................................
....................................................................................
....................................................................................
....................................................................................
....................................................................................
....................................................................................
....................................................................................
....................................................................................
....................................................................................
....................................................................................
....................................................................................
....................................................................................
...................................................lick..........lick..........................
...............lick.................................................................
....................................................................................
....................................................................................
....................................................................................
....................................................................................
....................................................................................
....................................................................................
....................................................................................
....................................................................................
....................................................................................
....................................................................................
....................................................................................
....................................................................................

........................................................................................

........................................................................................

........................................................................................

........................Emotions are eternal...............................

....................collective, and.........................................

.......................deeply material. It.................................

..............................licks the walls..............................

..............................of the cave..................................

........................................and.................................

......................................turns................................

........................................................................................

....................................them...................................

...................................into.....................................

........................................................................................

........................................................................................

................................stone.......................................

........................................................................................

........................................................................................

........................................................................................

........................................................................................

........................................................................................

........................................................................................

........................................................................................

........................................................................................

........................................................................................

........................................................................................

........................................................................................

References

Epigraphs
p.5: Emily Dickinson, *The Life and Letters of Emily Dickinson* (New York: Biblo & Tannen, 1971); Lauren Berlant, *Desire/Love* (New York: Punctum, Books, 2012).

clinging love
pp.10 and 11: Empedocles, *Fragments of Empedocles*, trans. John Burnet (Charleston, SC: CreateSpace, 2017); p.11: Alfred North Whitehead, *The Function of Reason* (Boston, MA: Beacon Press, 1971); p.11: Empedocles, *Fragments*; p.12: Robin Wall Kimmerer, *Braiding Sweetgrass: Indigenous Wisdom, Scientific Knowledge, and the Teachings of Plants* (Minneapolis, MN: Milkweed Editions, 2013); p.13: Audre Lorde, 'Uses of the Erotic', in *Sister Outsider: Essays and Speeches* (Berkeley, CA: Crossing Press, 1984); pp.13–14: Jeffrey Jerome Cohen, *Stone: An Ecology of the Inhuman* (London & Minneapolis, MN: University of Minnesota Press, 2015); p.14: James Baldwin in Jane Howard, 'Doom and Glory of Knowing Who You Are', *Life*, 24 May 1963; p.15: Mel Y. Chen, *Animacies: Biopolitics, Racial Mattering, and Queer Affect* (London & Durham, NC: Duke University Press, 2012); p.16: Luce Irigaray, *Elemental Passions*, trans. Joanne Collie and Judith Still (New York: Routledge, 1992); p.16: @pisshets (now @rednines), *Tumblr*, 24 February 2017; p.17: Lorde, 'Uses of the Erotic'; p.18: Empedocles, *Fragments*.

A Prescription from the Physicians of Myddfai
This text is based on the gastrointestinal and digestive cures in *The Physicians of Myddfai*, a collection of medieval Welsh medical texts. The numbering refers to the numerical entry of each specific cure. Terry Breverton, trans., *The Physicians of Myddfai: Cures and Remedies of the Medieval World* (Llandeilo: Cambria Books, 2013).

Celidonie
p.37: Francis Young, ed. and trans., *The Peterborough Lapidary: A Medieval Book of Magical Stones* (Cambridge: Texts in Early Modern Magic, 2016).

A Disputacioun Betwyx the Body and the Wormes
p.43: Anon., 'A Disputacioun Betwyx the Body and Wormes', mid-15th century; translation from Jenny Rebecca Rytting, 'A Disputacioun Betwyx Þe Body and Wormes: A Translation', in *Comitatus: A Journal of Medieval and Renaissance Studies*, 31/1 (2000); pp.43 and 44: the lines 'keep your solitude' and 'The way out is solitude' are from Simone Weil, *Gravity and Grace*, trans. Emma Crawford and Mario von Der Ruhr (London and New York: Routledge, 2002); p.44: the line 'why do you do thus? what makes you eat?', is from Rytting's translation of 'A Disputacioun Betwyx the Body and Wormes'; p.45: the line 'if we go

down into ourselves, we find that we possess exactly what we desire' is from Weil, *Gravity and Grace*; p.45: the line 'eating and being eaten belong to the terrible secret of love' is from Hélène Cixous, 'Love of the Wolf', in *Stigmata: Escaping Texts* (London and New York: Routledge, 1998); p.45: the line 'we come together in love, and are desired by one another' is adapted from Empedocles, *Fragments of Empedocles*, trans. John Burnet (Charleston, SC: CreateSpace, 2017); p.45: the line 'words made flesh, muscle and bone animated by hope and desire' is from Sylvia Wynter, 'The Pope Must Have Been Drunk, the King of Castile a Madman: Culture as Actuality and the Caribbean Rethinking of Modernity', in *Reordering of Culture: Latin America, the Caribbean and Canada in the 'Hood*, ed. A. Ruprecht & C. Taiana (Ottawa: Carleton University Press, 1995); p.45: the line 'when they are in strife all these are different in form and separated' is from Empedocles, *Fragments*; pp.45 and 47: the repeated line 'all the people who were alive, who had ever been alive' is from James Baldwin in Jane Howard, 'Doom and Glory of Knowing Who You Are', *Life*, 24 May 1963; p.45: the line 'for we have been ere now a boy and a girl, a bush and a bird and a dumb fish in the sea' is from Empedocles, *Fragments*; p.47: the lines 'we cannot calcify the present without killing it/ a deadening rigidity, a calcification, a sort of carapace' and 'the insistence of the world in its alterity, exigency, and unpredictability' are adapted from Lee Edelman in Lauren Berlant and Lee Edelman, *Sex, or the Unbearable* (Durham, NC: Duke University Press, 2014); p.47: the line 'from the earth issue forth things close-pressed and solid' is from Empedocles, *Fragments*; p.47: the line 'glistening and libidinous rocks' is from Jeffrey Jerome Cohen, *Stone: An Ecology of the Inhuman* (London & Minneapolis, MN: University of Minnesota Press, 2015); p. 47: the line 'is our strength the strength of stones?' is from Job 6:12; p.47: the line 'we are [all] moving towards the lithic' is from Cohen, *Stone*; p.47: the line 'everyone in love is oriented towards this absorption' is adapted from Cixous, 'Love of the Wolf'; p.48: the lines 'You have me for lunch and for supper at night,/ now gnawing and eating me right to the bone/ with a greedy, insatiable appetite./ there's no rest, for always you suck and bite', and 'You've had worms in your hands and fleas in your bed/ Or lice or nits in your hair each day,/ Also stomach-worms to plague you in every way,/ And venomous creatures, night and morning,/ To make you ready and give you warning', are from Rytting's translation of 'A Disputacioun Betwyx the Body and Wormes'.

Philadelphia
p.51: Friedrich Nietzsche, *The Gay Science*, trans. Walter Kaufmann (New York: Random House, 1974).

with your teeth
p.92: David Wojnarowicz, text from *When I Put My Hands on Your Body*, 1990, gelatin silver print and silkscreen text on museum board; p.92: Simone Weil, *Gravity and Grace*, trans. Emma Crawford and Mario von Der Ruhr (London and New York: Routledge, 2002); pp.93 and 94: Hélène Cixous, 'Love of the Wolf',

in *Stigmata: Escaping Texts* (London and New York: Routledge, 1998); p.95: Georges Bataille (attributed); p.95: Sándor Ferenczi, *Thalassa: A Theory of Genitality* (London: H. Karnac, 2005); pp.95–6: *Buffy The Vampire Slayer*, 'After Life', season 6, episode 3 (2001); p.96: Audre Lorde, 'Uses of the Erotic', in *Sister Outsider: Essays and Speeches* (Berkeley, CA: Crossing Press, 1984); p.96: Cixous, 'Love of the Wolf'; p.97: Lee Edelman in Lauren Berlant and Lee Edelman, *Sex, or the Unbearable* (Durham, NC: Duke University Press, 2014); p.97: Julian of Norwich, *Showings*, ed. and trans. Edmund Colledge and James Walsh (Mahwah, NJ: Paulist Press, 1978); p.98: *The Prickynge of Love*, 14th century, quoted in Sarah Beckwith, *Christ's Body: Identity, Culture and Society in Late Medieval Writings* (London and New York: Routledge, 1993); p.98: Beckwith, *Christ's Body*; pp.98–9: Cixous, 'Love of the Wolf'.

Mirror Mirror
p.101: Plato, *Plato in Twelve Volumes*, vol. 9, trans. Harold N. Fowler (Cambridge, MA: Harvard University Press, 1925); pp.101 and 102: Lucretius, *On the Nature of Things*, trans. W. H. D. Rouse, revd Martin F. Smith (Cambridge, MA: Harvard University Press, 1989); p.103: Aristophanes in Plato, *The Symposium*, trans. Christopher Gill (London: Penguin, 2003); p.105: Lucretius, *On the Nature of Things*; p. 106: Aristophanes in Plato, *Symposium*.

Topaz
p.113: Francis Young, ed. and trans., *The Peterborough Lapidary: A Medieval Book of Magical Stones* (Cambridge: Texts in Early Modern Magic, 2016).

frank r jagoe's work is a reclamation of madness and monstrosity in opposition to the exclusionary category of the human. Often it explores communication with other-than-humans: in recognition that we are in community with each other; in acknowledgement of the personhood of other-than-human beings; and in order to displace a Western hierarchy that claims humanity as the highest form of existence. They are particularly drawn to considering how madness and monstrosity are defined in relation to language usage, and in opposition to rationality, coherence, and 'reason'. Highlighting forms of communication beyond words, beyond class-based language, beyond human forms of speech, feels an urgent imperative. Throughout they want to consider whose language is respected, whose language is engaged with, and believed, or even acknowledged.

Influenced by medieval lapidary texts, jagoe's most recent focus has been finding kinship with rocks, and trying to think through how we can communicate across vastly different experiences of time. They are also currently trying to make friends with a group of crows in Victoria Park.

The Prototype Prize was established in 2024 to celebrate the work of writers and artists working at the intersections of different literary and artistic forms. It was judged in its inaugural year by Bhanu Kapil, Tom McCarthy and Elizabeth Price, and run by Prototype and Monitor Books, in partnership with *frieze* magazine, awarding categories for both book-length and short-form works.

frank r jagoe (formerly Rebecca Jagoe) won the book-length category, receiving a prize of £3,000 plus publication by Prototype, while Remi Graves won the short-form category, with a prize of £2,000 plus publication by Monitor Books.

The prize was run in conjunction with an adjacent development programme in partnership with New Writing North, supporting under-represented and emerging writers and artists through a six-month long scheme consisting of monthly seminars with leading practitioners, and editorial development and group feedback sessions,

The Prototype Prize was supported by Shane Akeroyd, Sadie Coles and Emmanuel Roman, and by public funding from Arts Council England.

The shortlists for the 2024 prize were:

BOOK-LENGTH CATEGORY

Matthias Connor: *Loose Fit*
Ellen Dillon: *A Whale Called Milieu*
frank r. jagoe: *Significant Others*
Kate Pickering: *There is a Miracle In Your Mouth*
Oliver Zarandi: *Body Horror*

SHORT-FORM CATEGORY

Aisha Farr: *Get-Up*
Remi Graves: *coal*
Krystle Patel: *Start with the present*
Milo Thesiger-Meacham: *Audible Heat*

*Prototype*
*Prize*

Supported using public funding by

**ARTS COUNCIL**
**ENGLAND**
LOTTERY FUNDED

*Significant Others* by frank r jagoe
Published by Prototype in 2025

The right of frank r jagoe to be identified as author of
this work have been asserted in accordance with Section 77 of
the UK Copyright, Designs and Patents Act 1988.

Design by Matthew Stuart & Andrew Walsh-Lister
(Traven T. Croves)
Typeset in Kleisch
Printed in Estonia by Tallinna Raamatutrükikoda

*Significant Others* was the winner of the Prototype Prize
2024, supported by Shane Akeroyd, Sadie Coles and Emmanuel
Roman, and by public funding from Arts Council England.

ISBN  978-1-913513-75-7

(  )   (           )   p     prototype

(type 3 – interdisciplinary projects)
www.prototypepublishing.co.uk
@prototypepubs

prototype publishing
71 oriel road
london e9 5sg
uk